DragonArt Ultimate Gallery

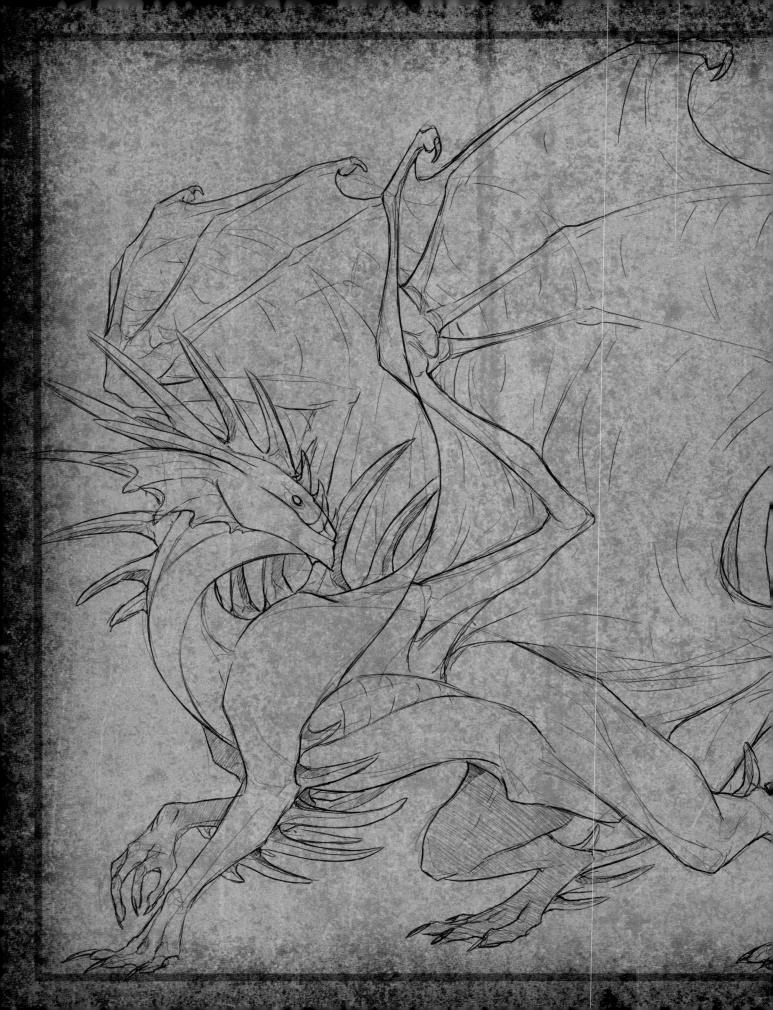

DRAGONART ULTIMATE GALLERY

More than 70 dragons and
other mythological creatures

J "NEONDRAGON" PEFFER

IMPACT
CINCINNATI, OHIO
www.impact-books.com

CONTENTS

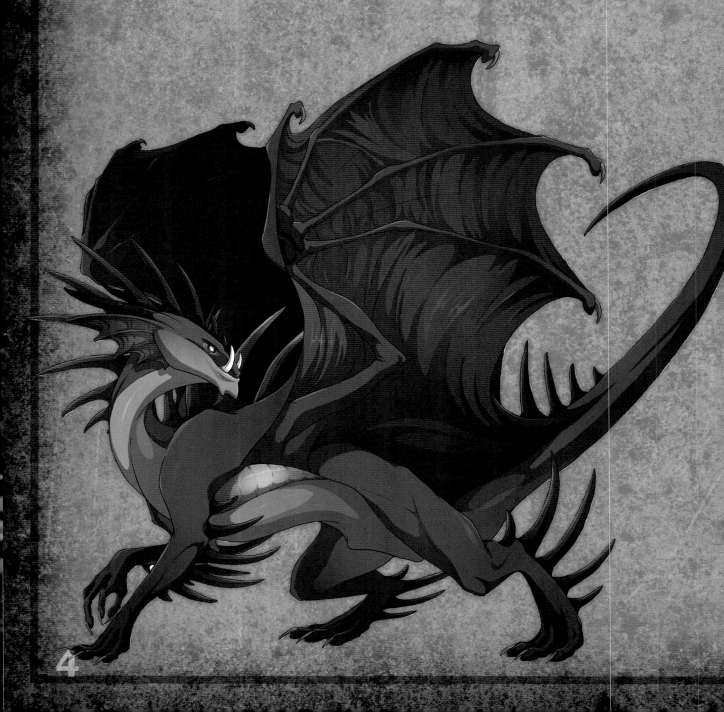

INTRODUCTION

Illustration is something I'm always excited about. I love the act of turning to a crisp page of unblemished sketch paper or a brand new Adobe® Photoshop® file and taking that short pause before beginning a new drawing. I love taking something that exists only as an idea in my head and creating a tangible image that I can share with others.

This book is a collection of some of the characters and creatures that make frequent stays in the nooks and crannies of my imagination.

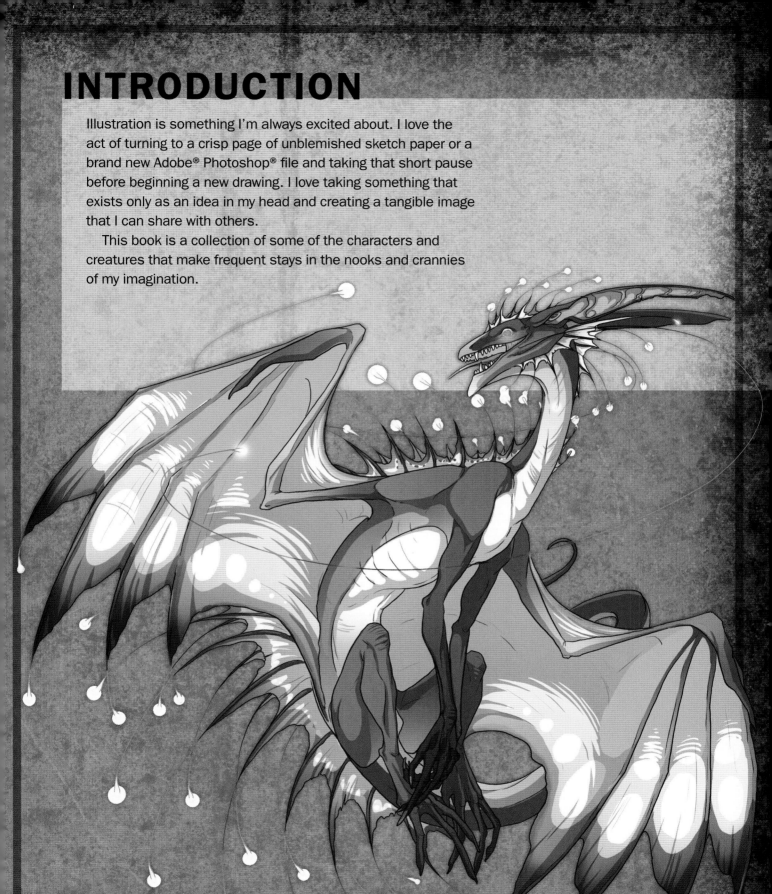

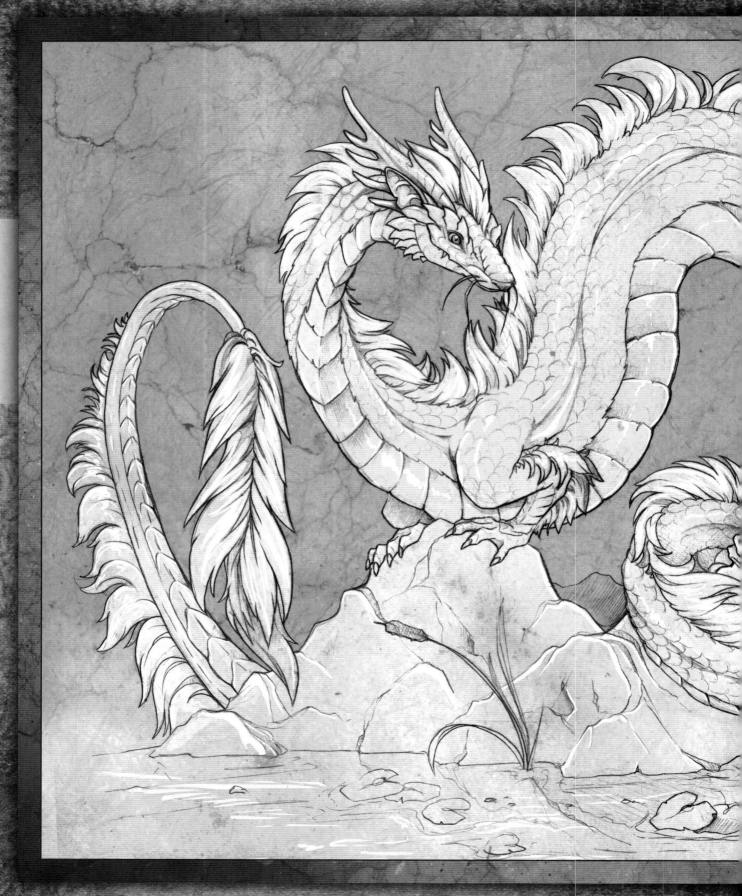

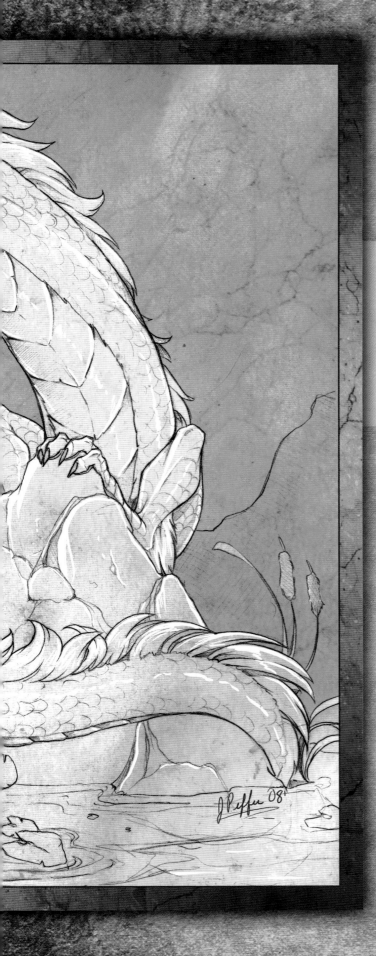

River's Reflection

WATER

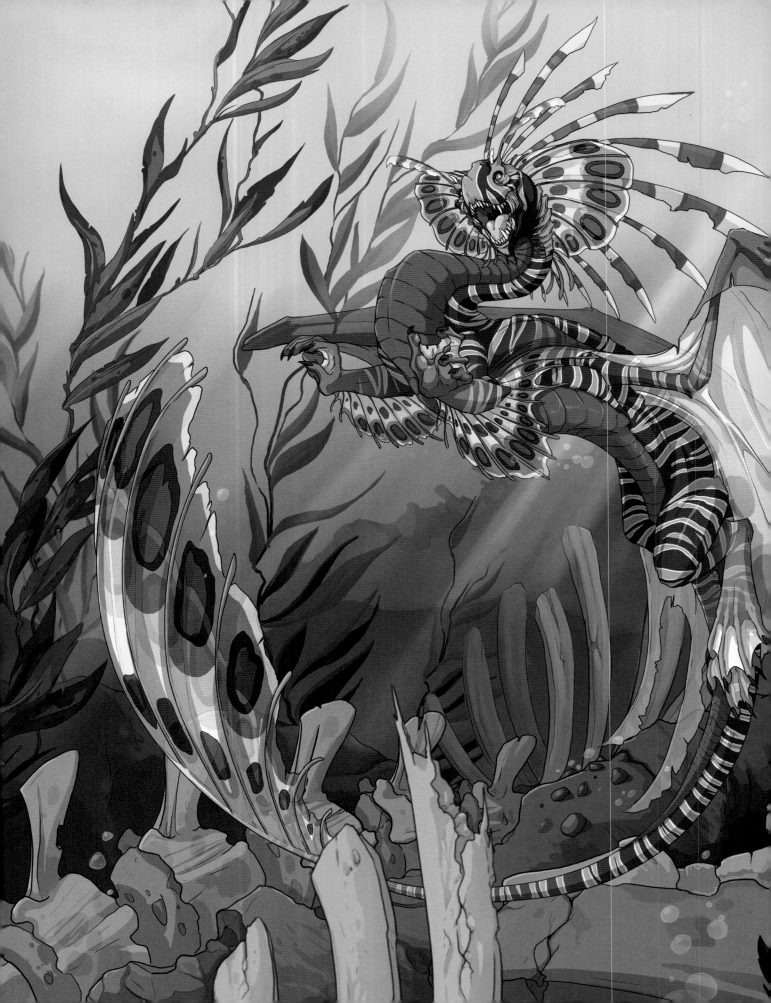

TIDECALLER

This dragon was a first pass at the water flight deity/leader for the *Flight Rising* game. This design was discarded because, while it ended up being a very spiffy dragon, it didn't seem to click as something a player would associate as an elemental dragon or a force more powerful than the other dragons in the game.

The illustration was created to show the Tidecaller (who later became the Tide Lord) in one of the game's locations, Fishspine Reef—a graveyard for some of the larger things that dwell in the depths.

The water flight in the *Flight Rising* game is associated with a deep blue color, so we wanted the Tidecaller to be mostly blue. The markings themselves are loosely based on a lion fish's striking markings.

MONSTER KISSES

One person's monster is
another person's big softy.

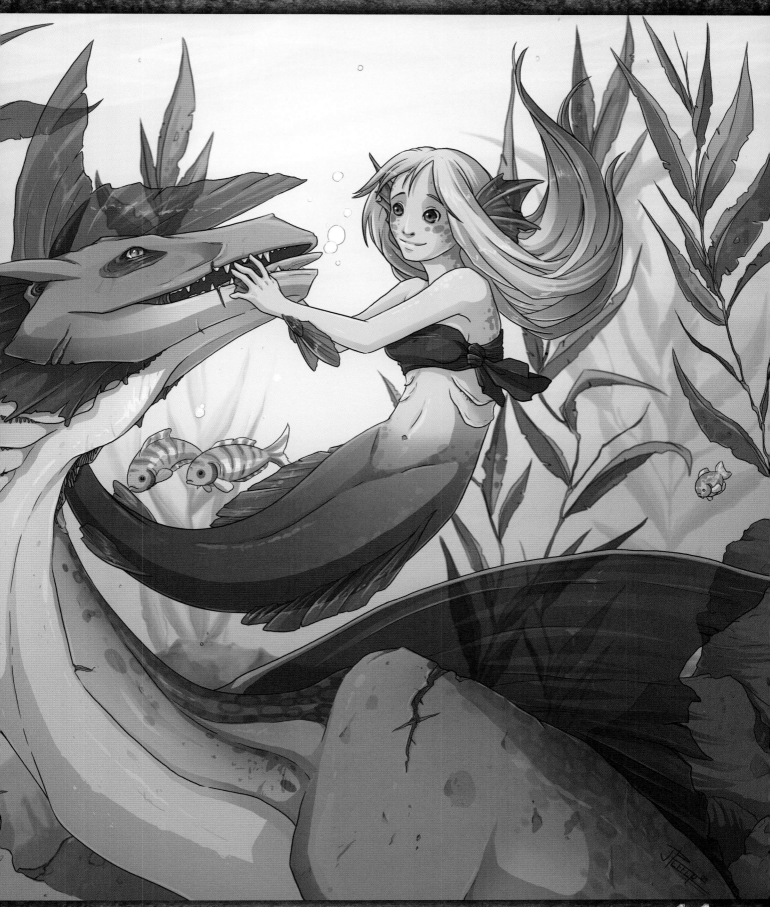

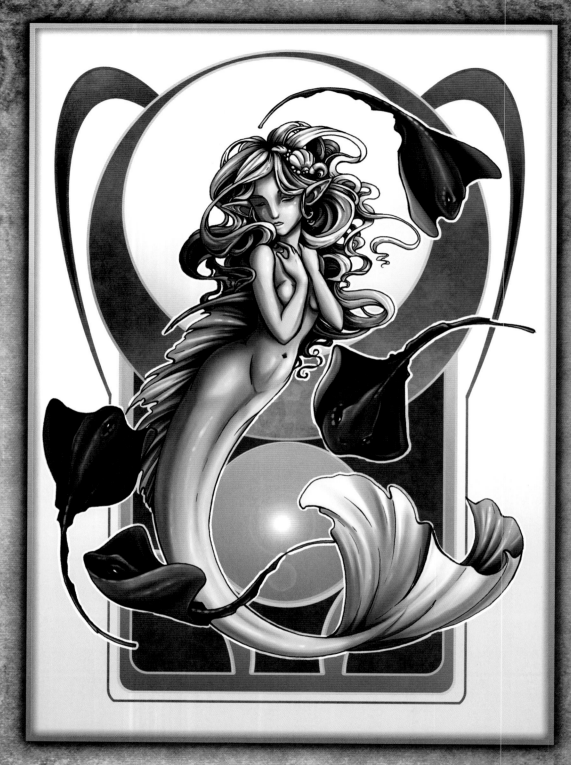

MERMAID

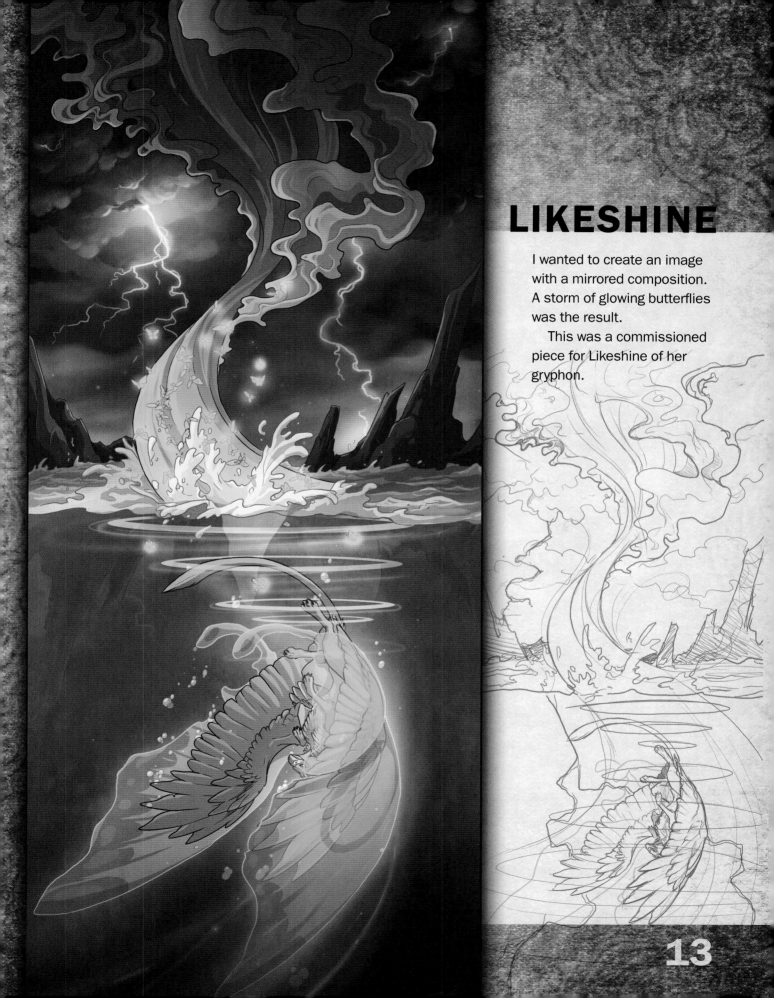

LIKESHINE

I wanted to create an image with a mirrored composition. A storm of glowing butterflies was the result.

This was a commissioned piece for Likeshine of her gryphon.

FROSTBITE

Here is some insight into the process behind my drawing of the Frostbite fairy.

First, I digitally inked a sketch using a 4 pixel hard, round brush. Then I created a new layer behind the inking and painted in a loose background in shades of blue. I created a leaf arrangement on a separate set of layers so I could pull the leaves out at a later point.

Next, I dropped in some black borders to frame the fairy. Since I had created the leaves on their own set of layers, they were easy to arrange above the black. I laid in flat colors on the body of the fairy.

Finally, I painted in icicles above the leaves and across the spiral twig that the fairy carries with her. I painted a delicate pattern in the fairy's wings, reminiscent of a dragonfly's wings.

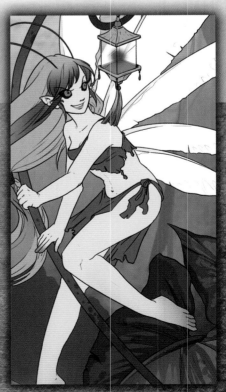

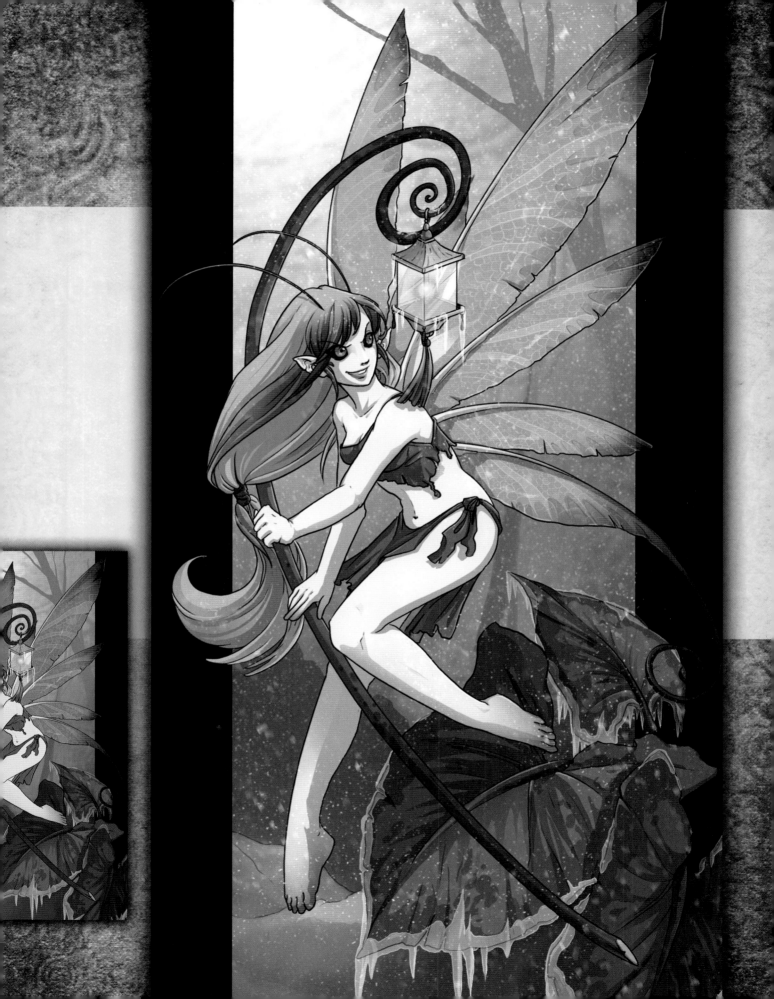

FROST DRAGON

To create this frost dragon, I sketched the dragon digitally using Photoshop CS3. Then, I created a new layer above the sketch and used a hard round brush to ink the dragon with clean linework.

Once I was satisfied, I created a simple background using a gradient. I then used a variety of soft brushes to add some texture and painted in a very loose sky. Above this, I added shards of ice in their own layer.

I laid some flat colors for my "white" dragon, using shades of gray and light blue to add texture and variety. There's a light spotted pattern to his wings.

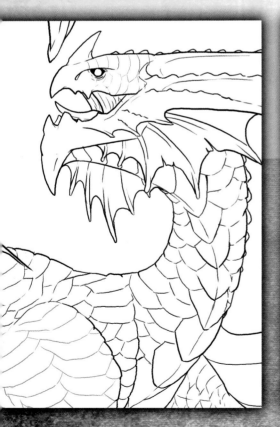
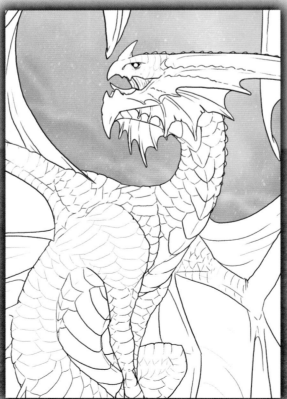

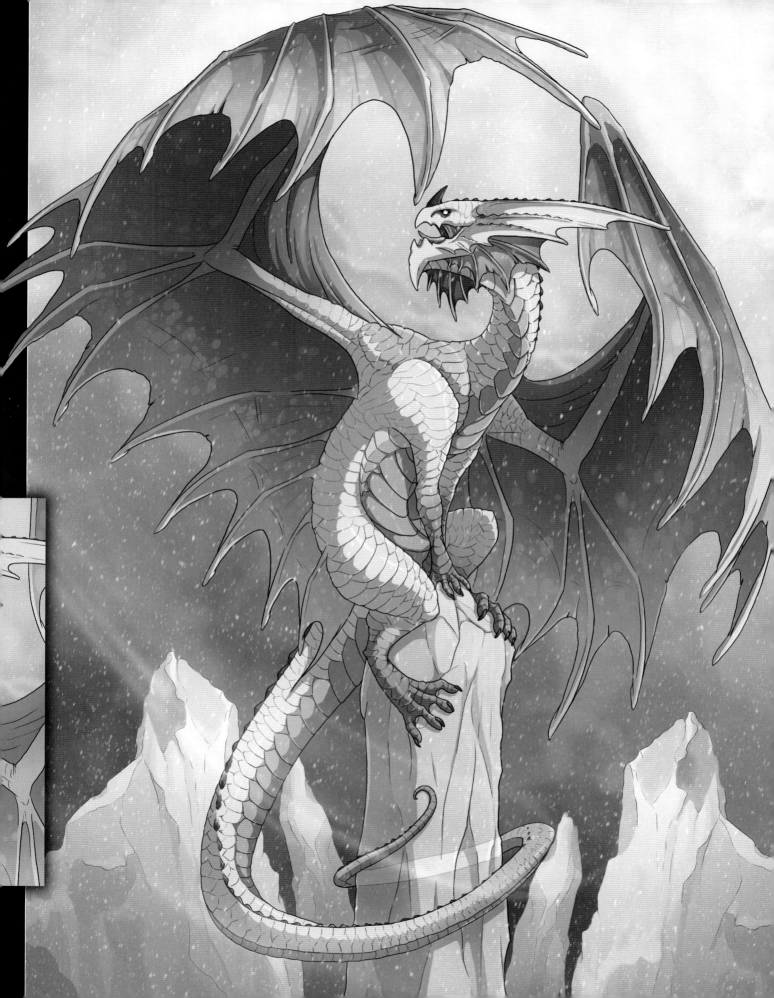

LIGHTWEAVER

This was a pass at the Lightweaver, another of the elemental leader concepts I later reworked for the *Flight Rising* game. The setting is one of the canals that runs through Hewn City—a city in ruins. The city's original occupants are long since deceased, the remains claimed by the Light Flight.

We wanted a warm light source from both the sun and the glowing wings. I went with a salmon-colored dragon so the gold of the wings would stand out against the body.

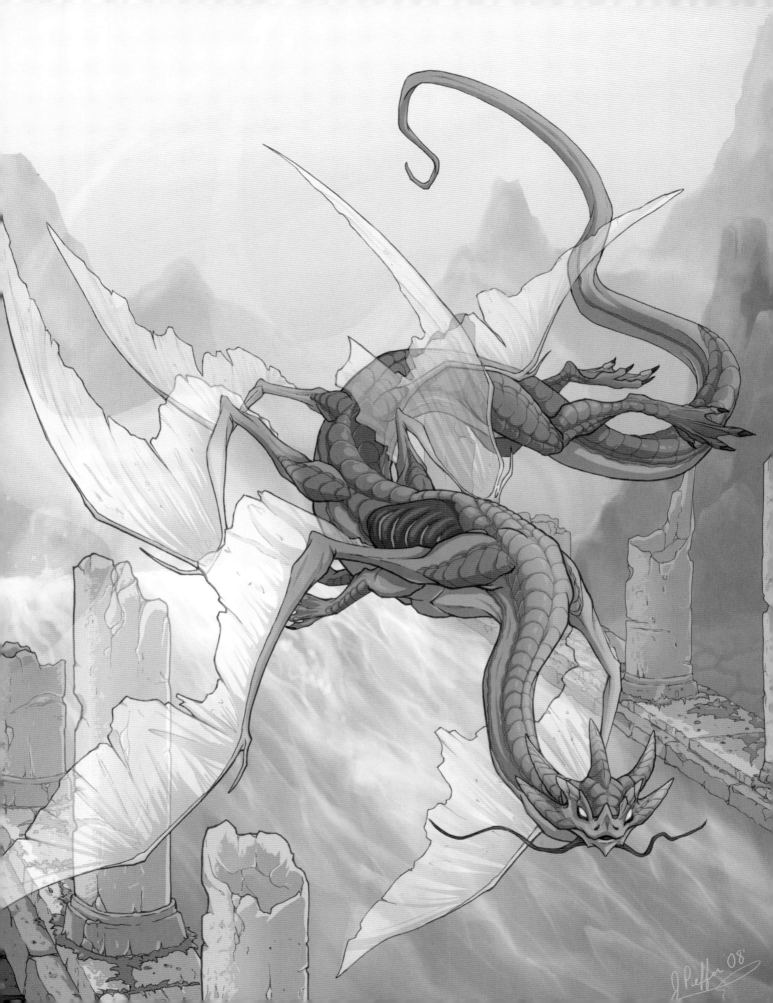

NEEKO

This was a commissioned work for Shynjy, showing his sea serpent Neeko along with his human companion. In this illustration, Neeko's powerful coils churn the waters as he is summoned. You can see how it progressed from sketch to finish.

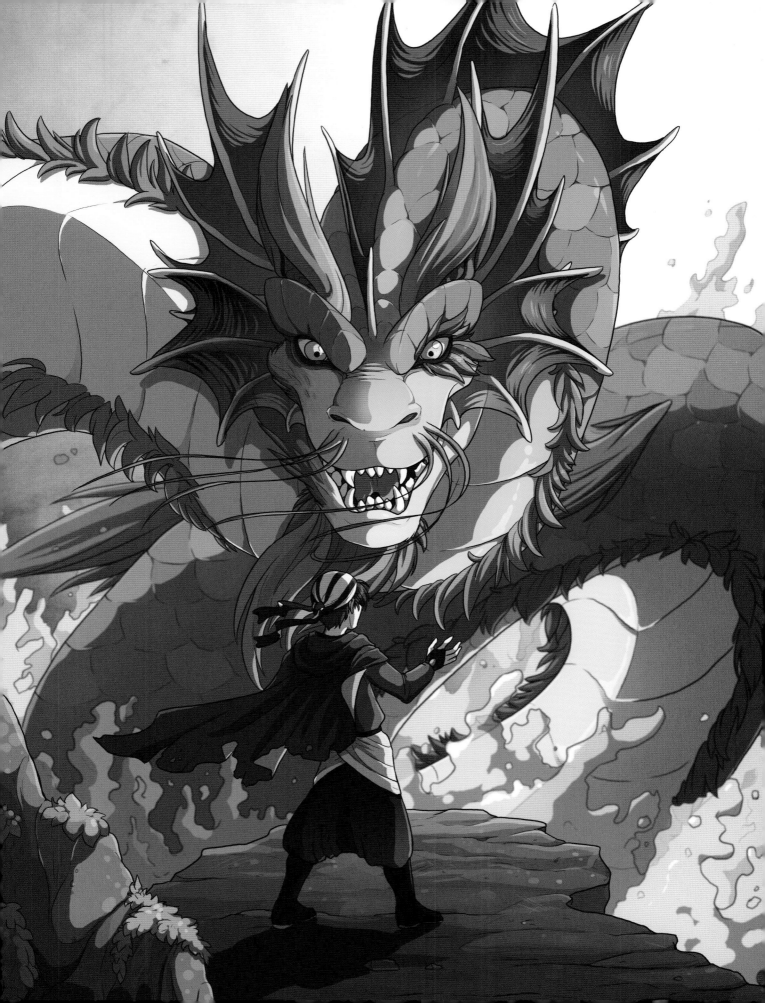

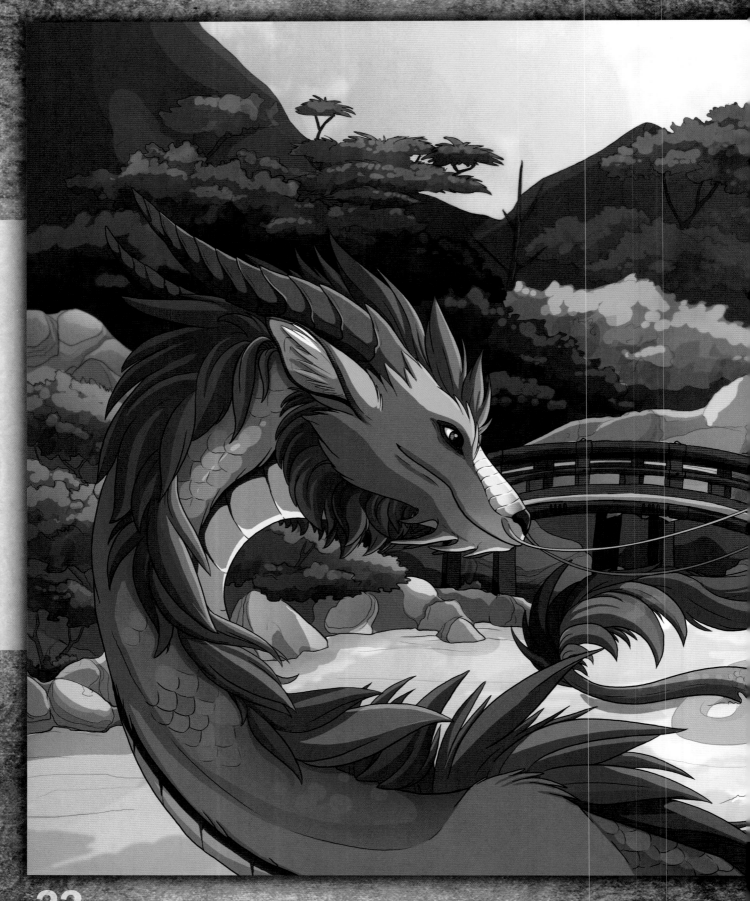

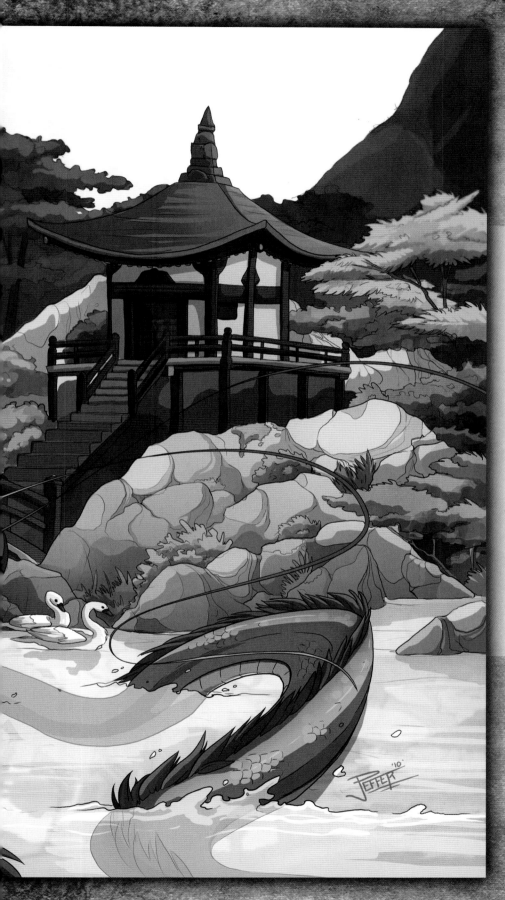

TOKENEKIE

This was a commissioned work for Tokenekie, of his dragon character of the same name. Tokenekie's design shared many qualities with Eastern dragons. A visit from an Eastern dragon is often auspicious. Because they are associated with water, I thought a tranquil setting depicting the dragon in its element, watching over a temple, made for interesting imagery.

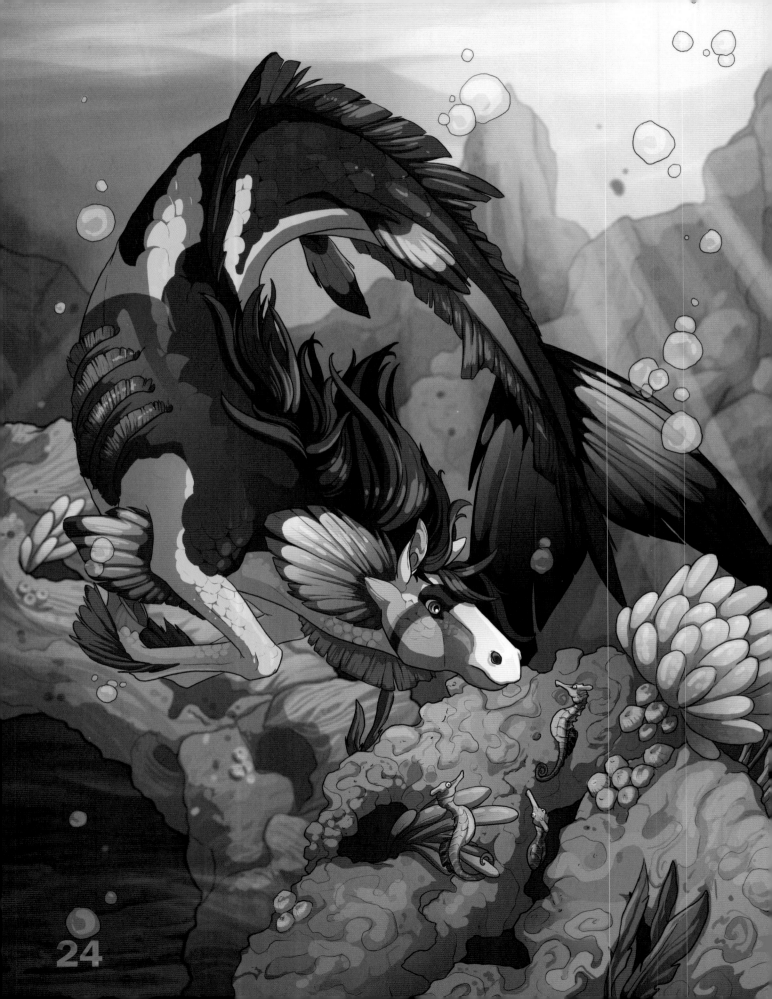

HIPPOCAMP

I sketched this hippocamp using a hard round brush with the flow and opacity turned down. The drawing is inked using a hard round brush on a layer above the sketch, resulting in clean linework.

Then I painted in the background and middle ground. For the arch of coral behind the hippocamp, I created a separate layer set with its own inks, flat colors and shadows. I was able to blur the layer set, making it a bit softer than the objects in the foreground.

I painted in the flat colors of the hippocamp using tropical fish as inspiration.

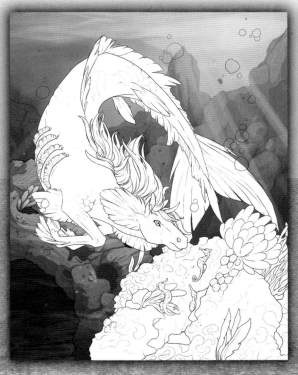

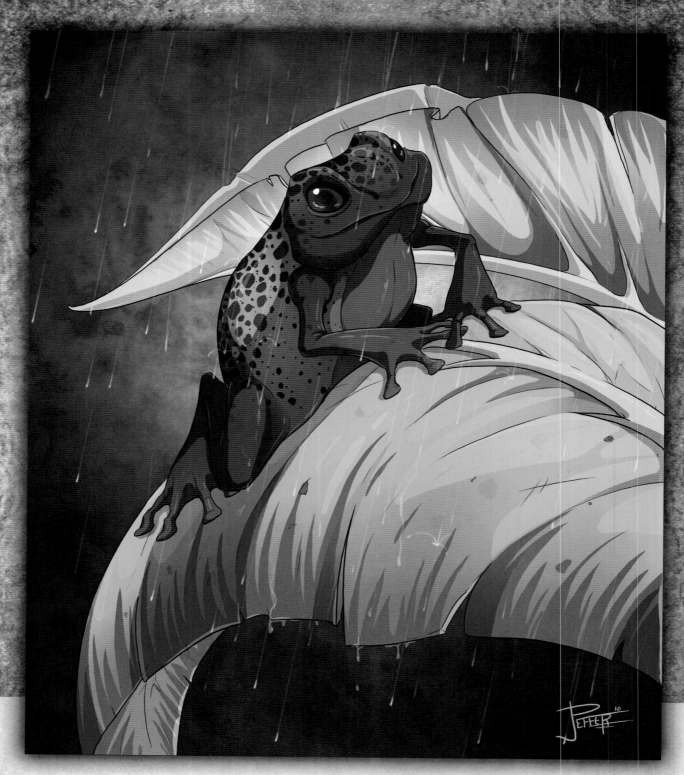

BLUE DART

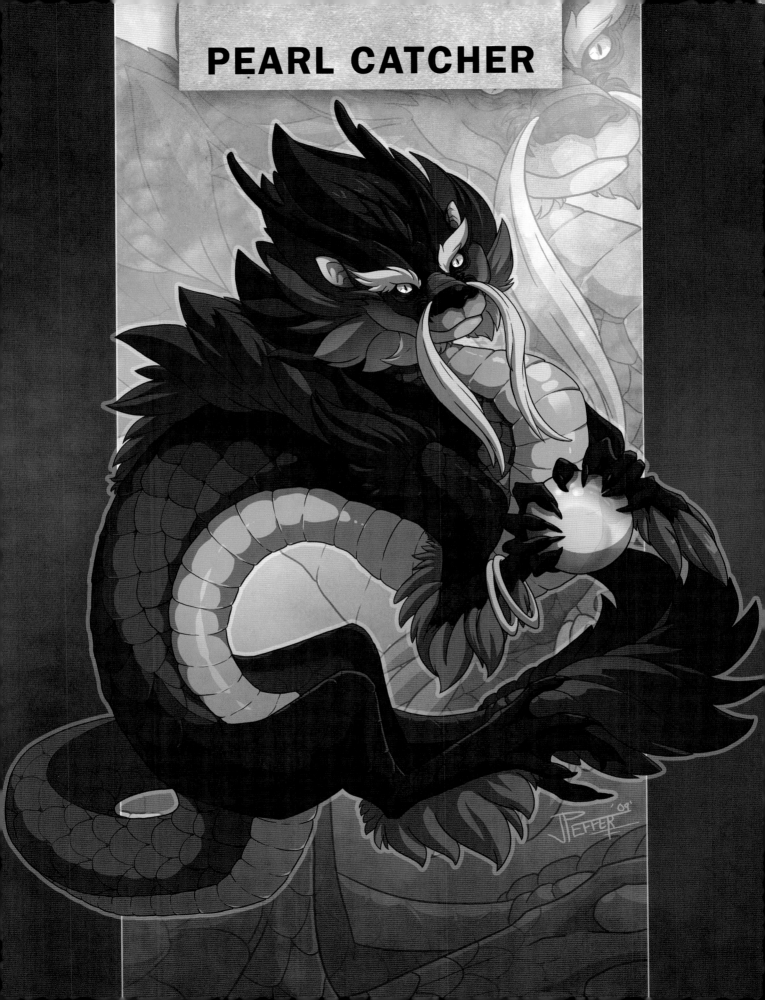

PEARL CATCHER

EARTH

Earthshaker

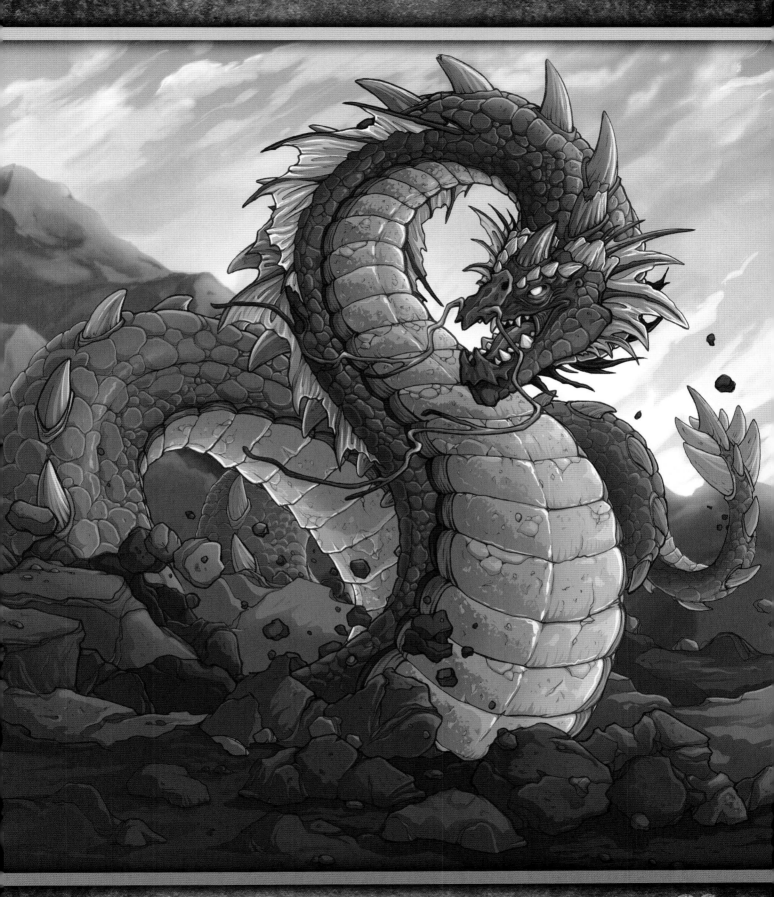

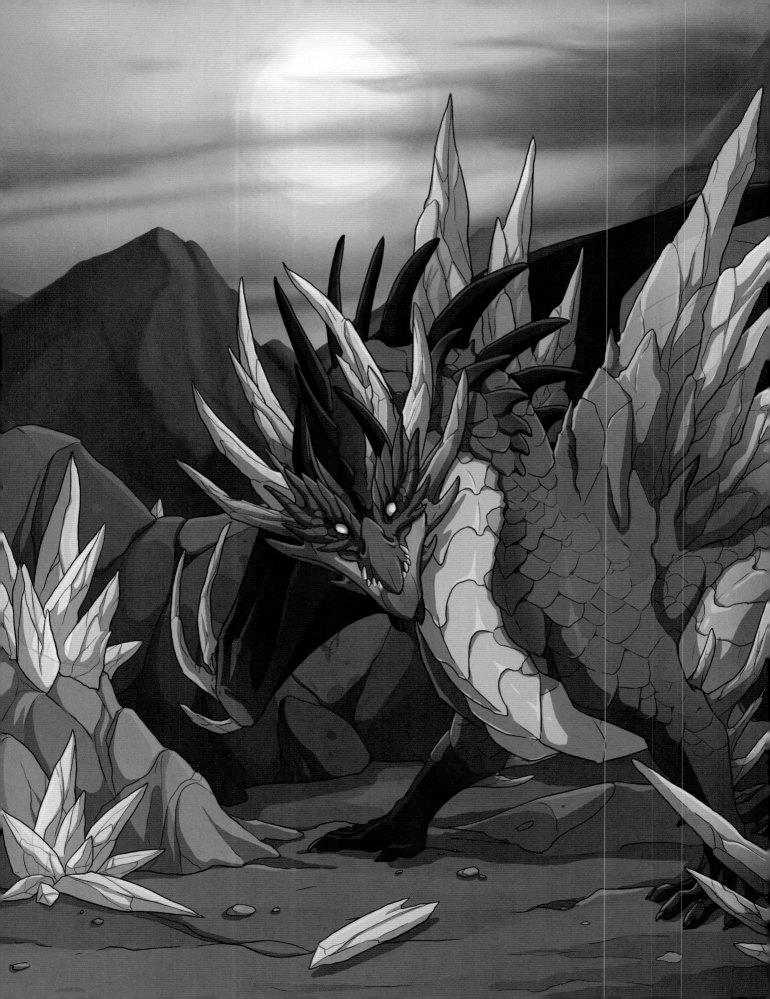

SPIKED DRAGON

When creating a setting for my dragons, I often try to create an environment where the dragon might be well adapted, camouflaged to facilitate more successful hunts. In the case of this dragon, his scales and spines are of a similar quality to the crystals and rocks surrounding him. I like to imagine that if he was motionless and you weren't staring directly at him, you wouldn't know he was there.

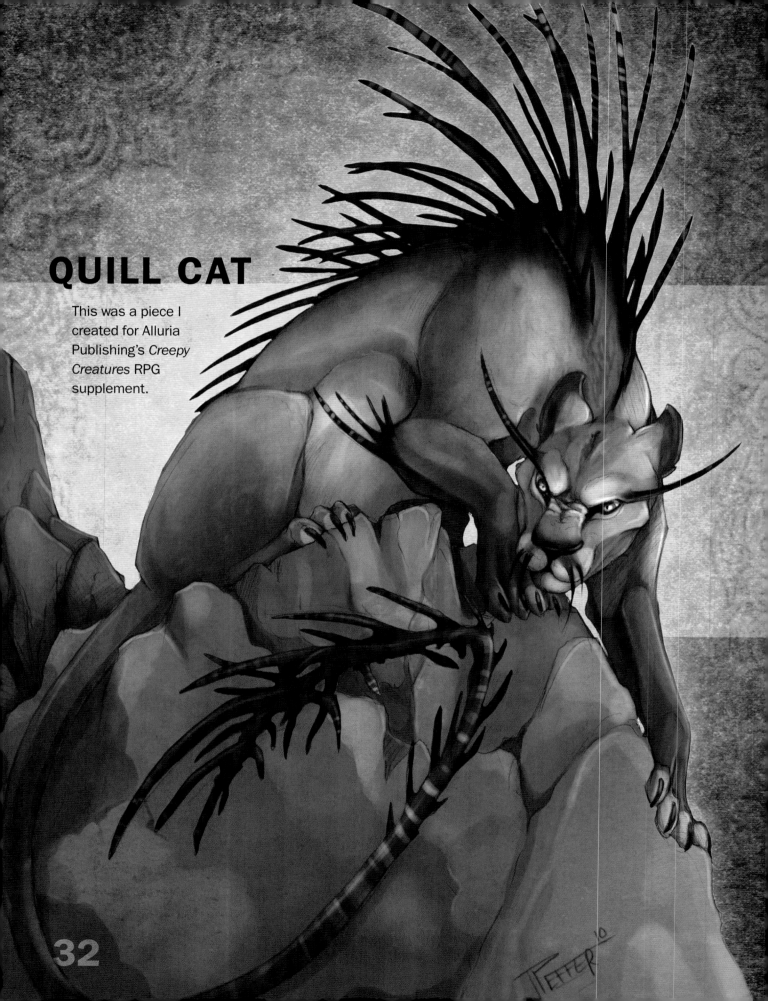

QUILL CAT

This was a piece I created for Alluria Publishing's *Creepy Creatures* RPG supplement.

CRAG PROWLER

The mountain range northeast of the Viridian Labyrinth is home to a variety of flora and fauna. Three prides of gryphon made their home in these rocky crags.

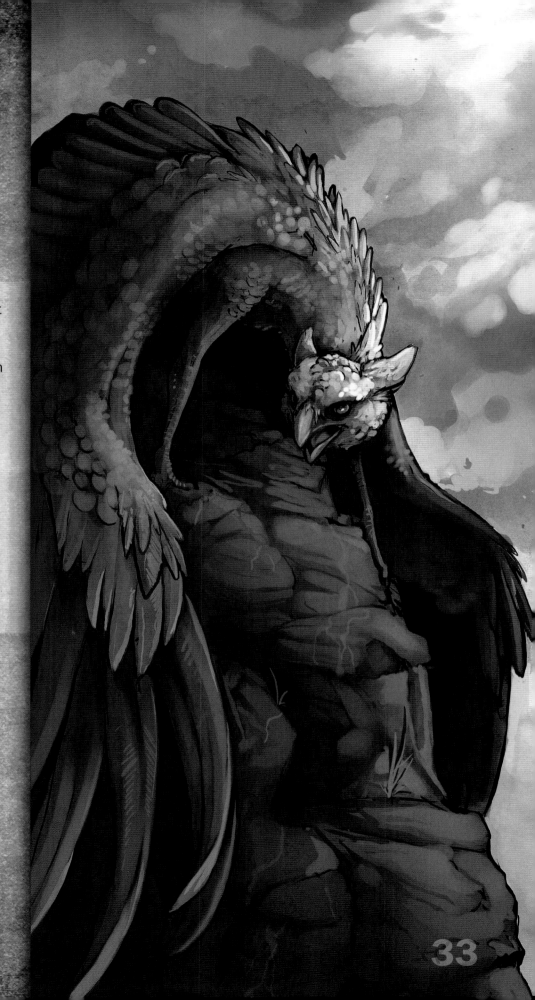

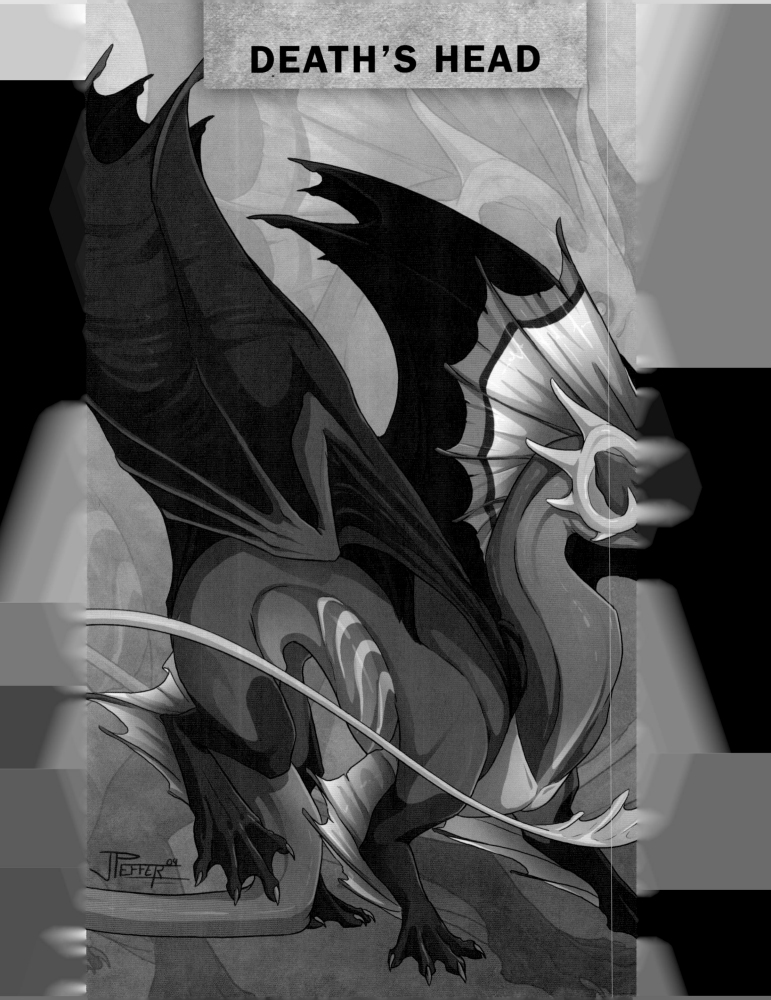

DEATH'S HEAD

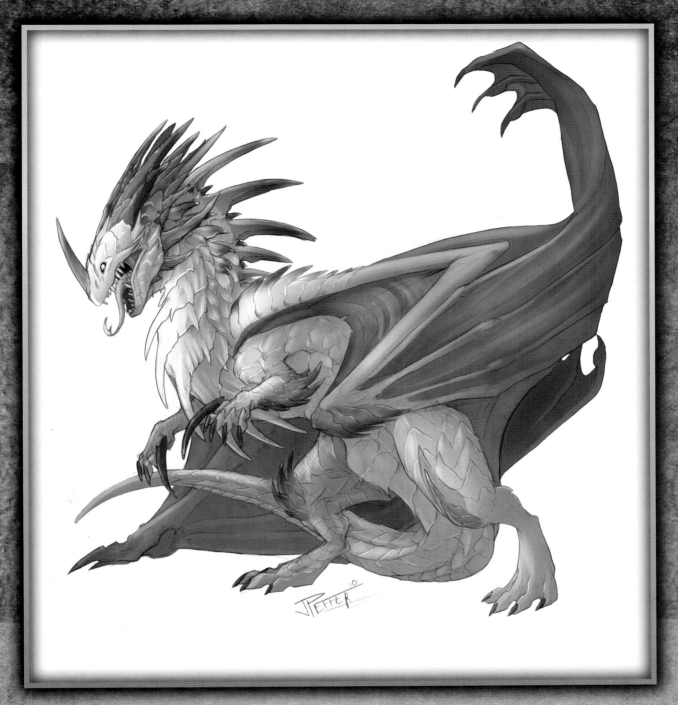

SALTHEAD DRAGON

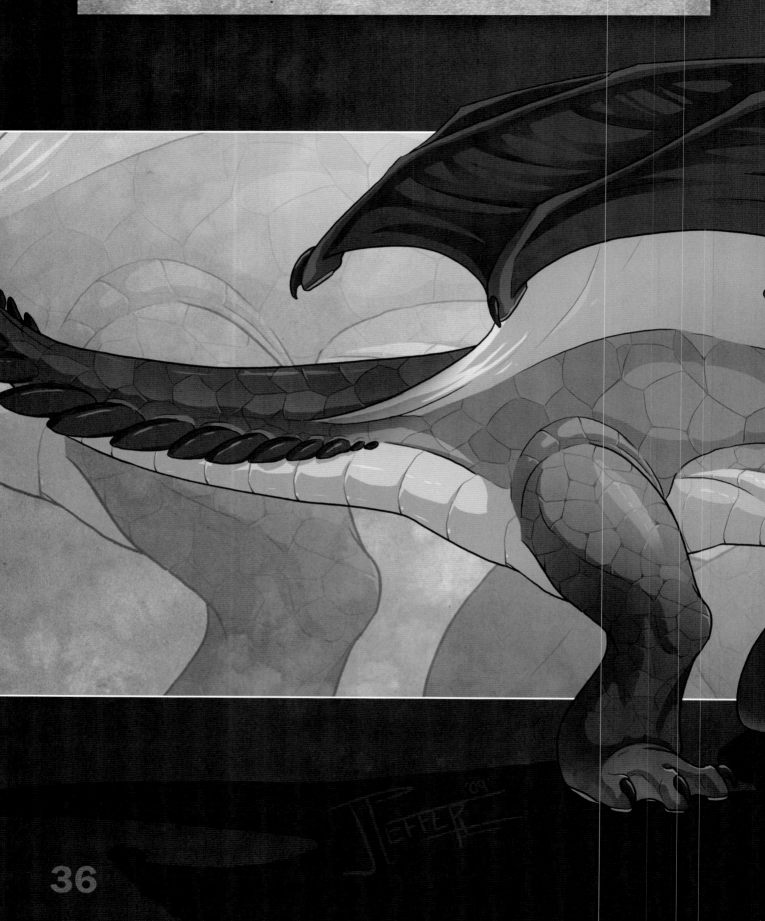

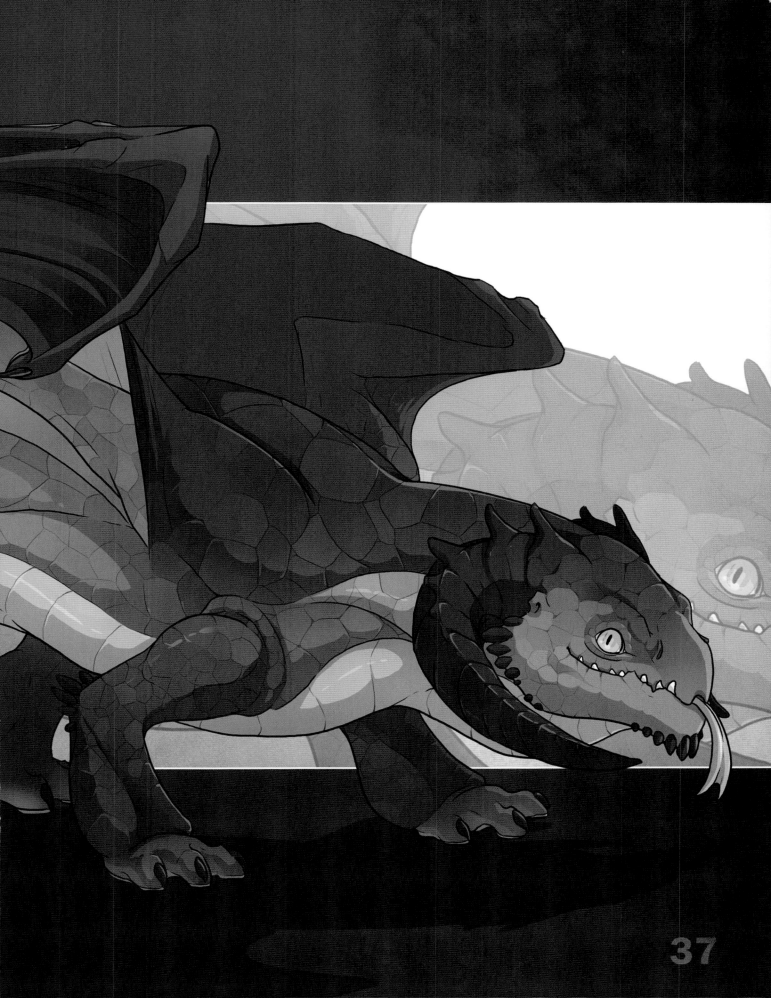

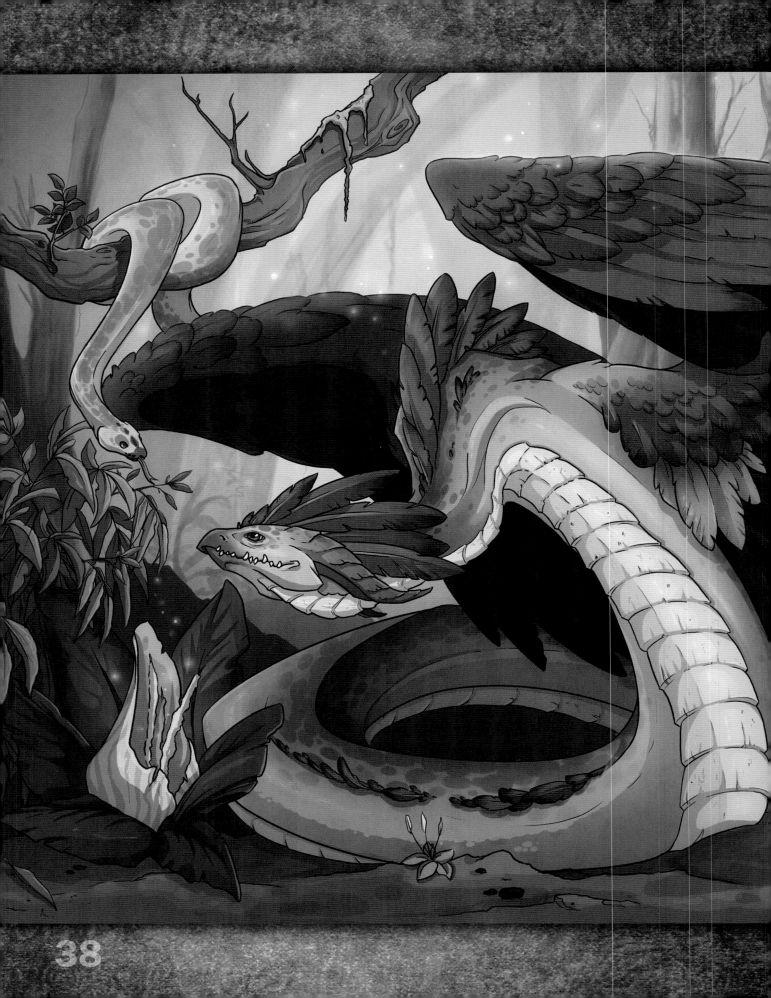

QUETZALCOATL

This image was created over the course of three years. The image itself did not take three years to draw. I drew this feathered serpent as part of my daily sketch effort in 2007. In 2008, I decided I liked it enough to ink and color. I stopped working on the image because I did not know quite what to do with the setting since I had essentially drawn a serpent floating in space. I set it aside and returned to it in 2009 to finally finish it!

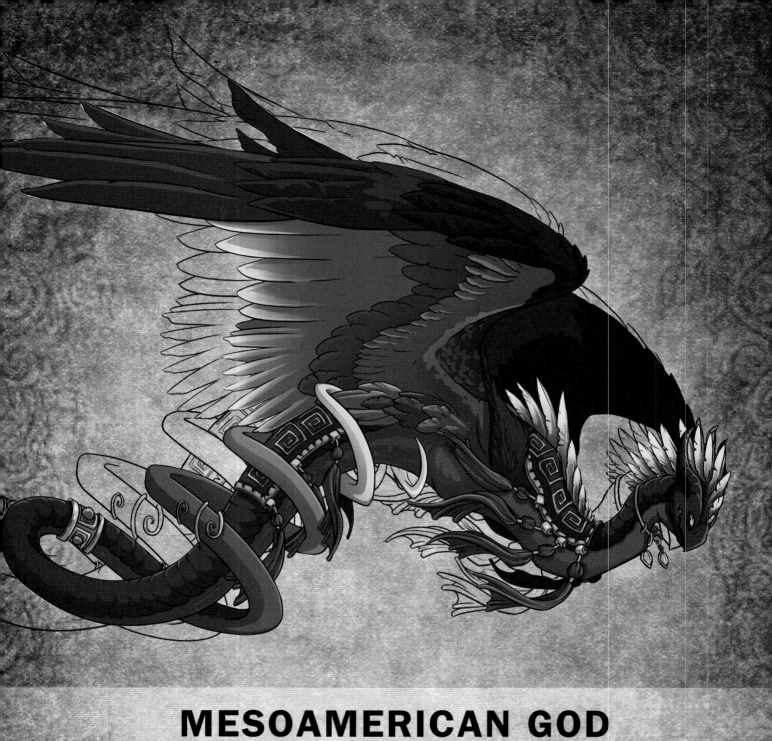

MESOAMERICAN GOD

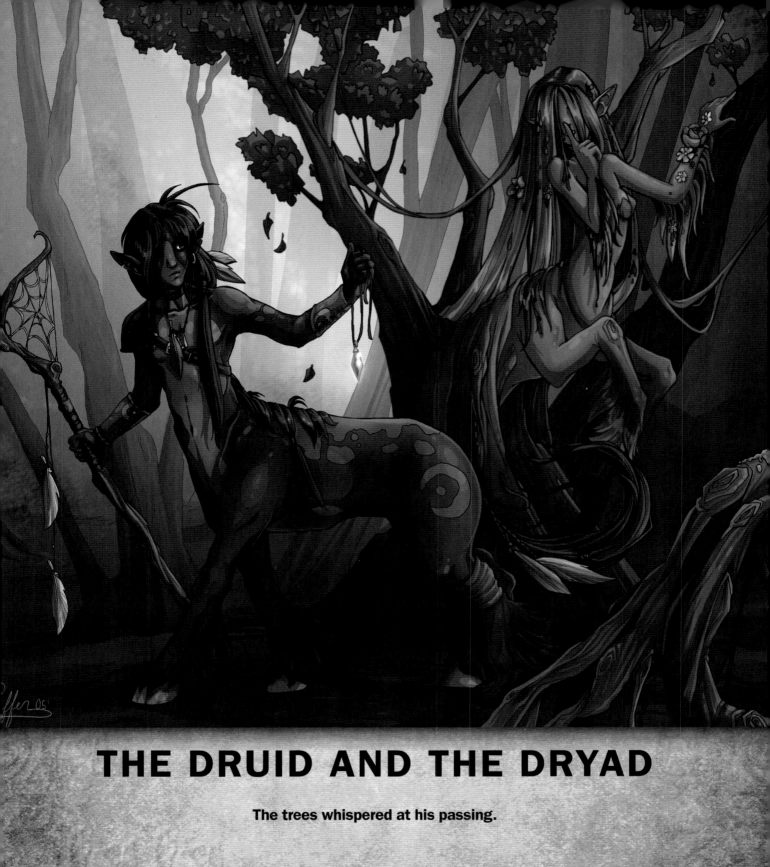

THE DRUID AND THE DRYAD

The trees whispered at his passing.

FOREST RUN

This image was a commissioned piece for Slither of his green dragon. I wanted the dragon to appear to have just landed and be running deeper into the pine forest. It made sense that the clearing behind her would be the area of the image providing the most light, so I placed the light source behind her.

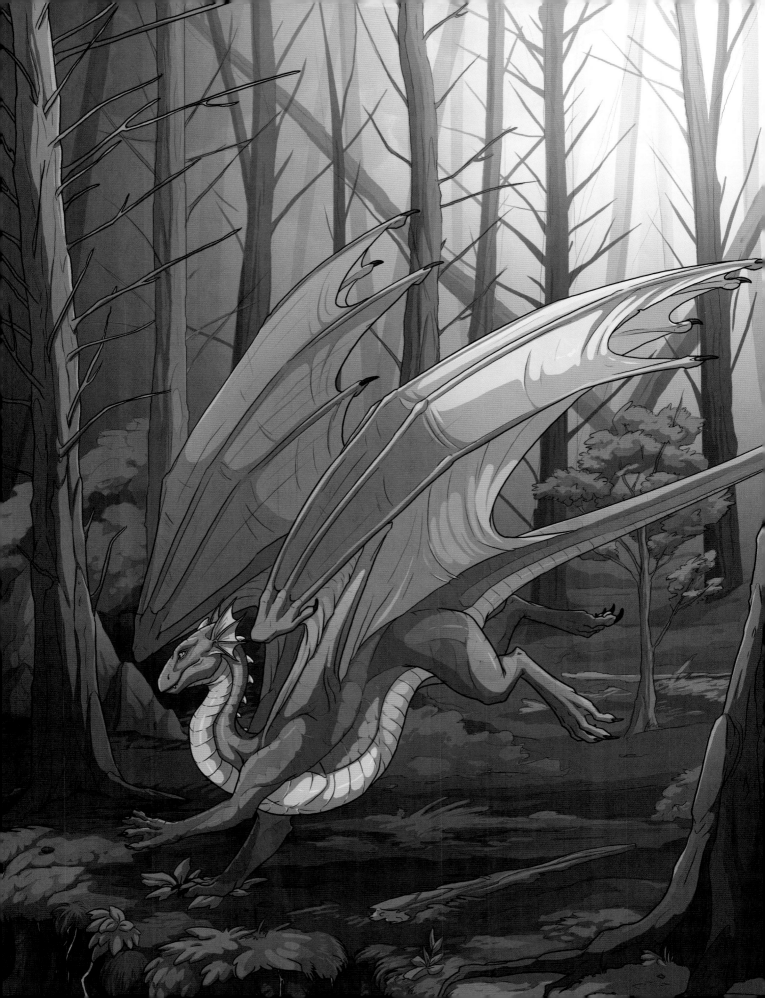

FAIRY DRAGONS

See how these progress from sketch to finished painting.

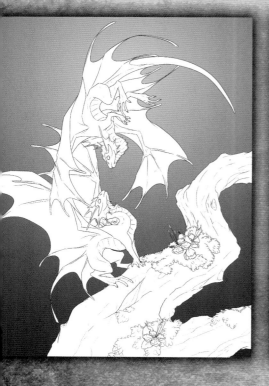
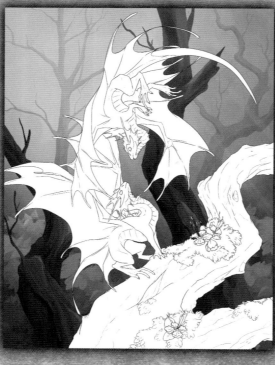
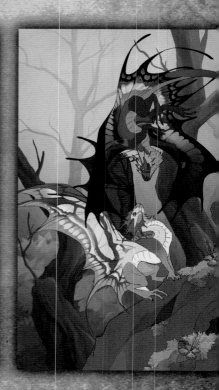

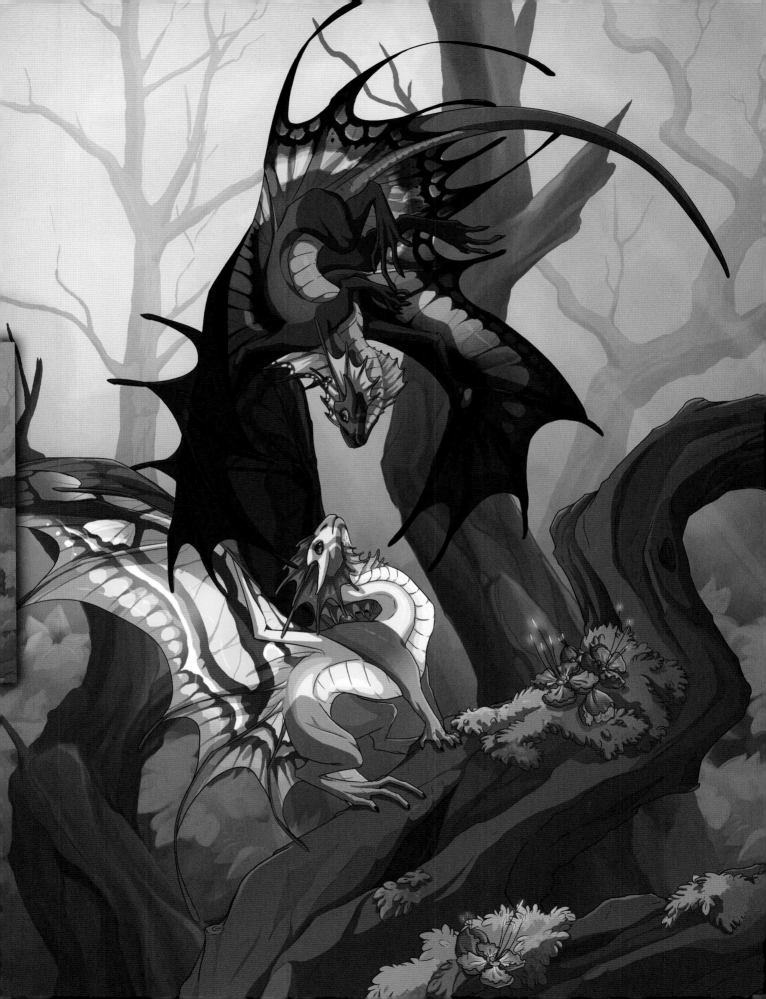

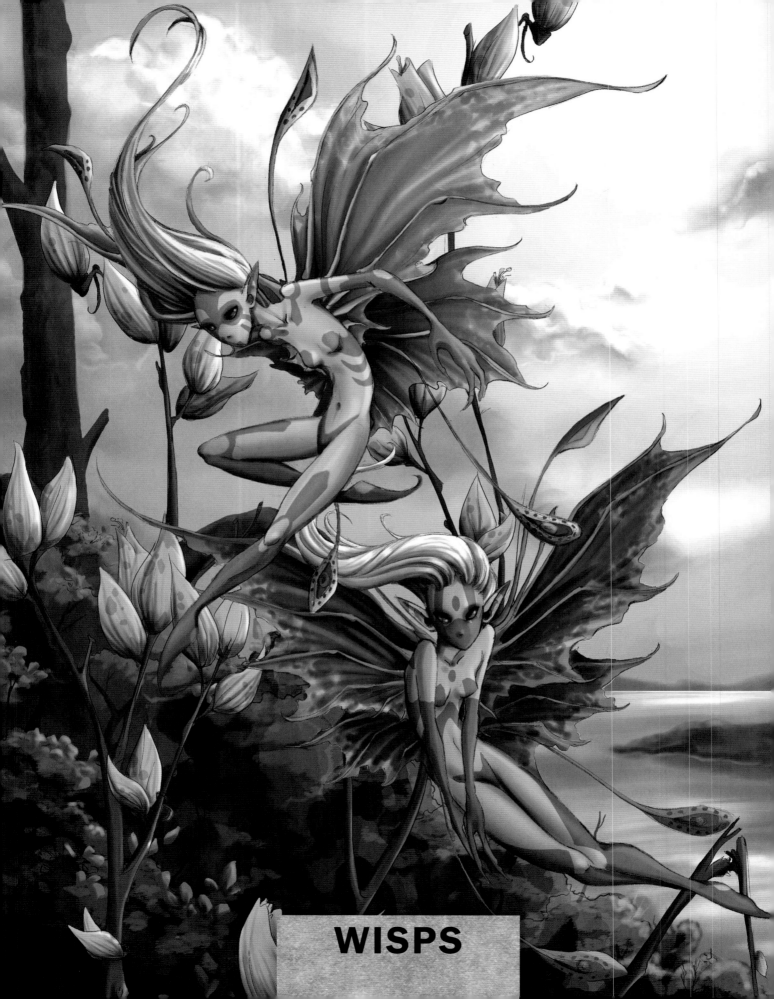

WISPS

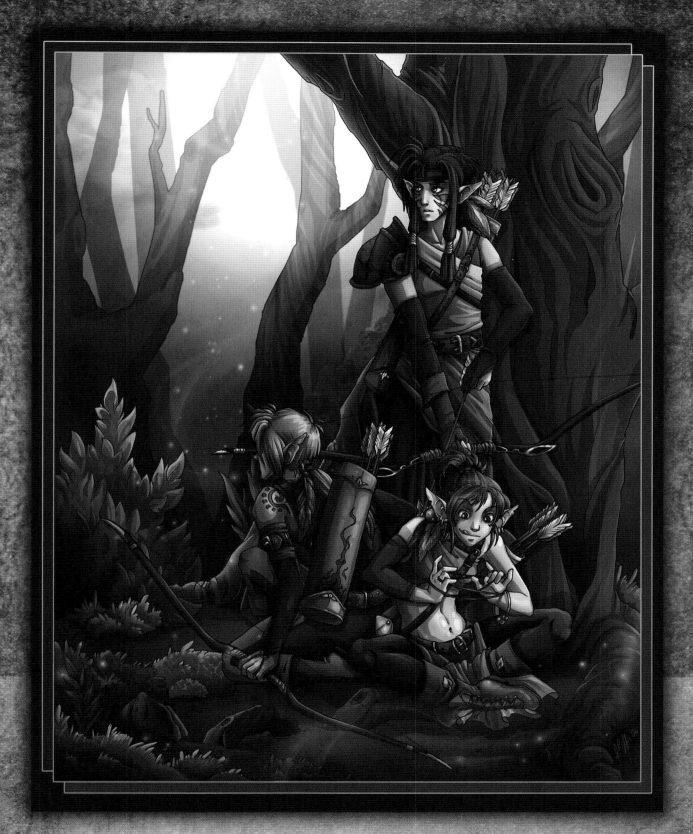

DEEP CONCENTRATION

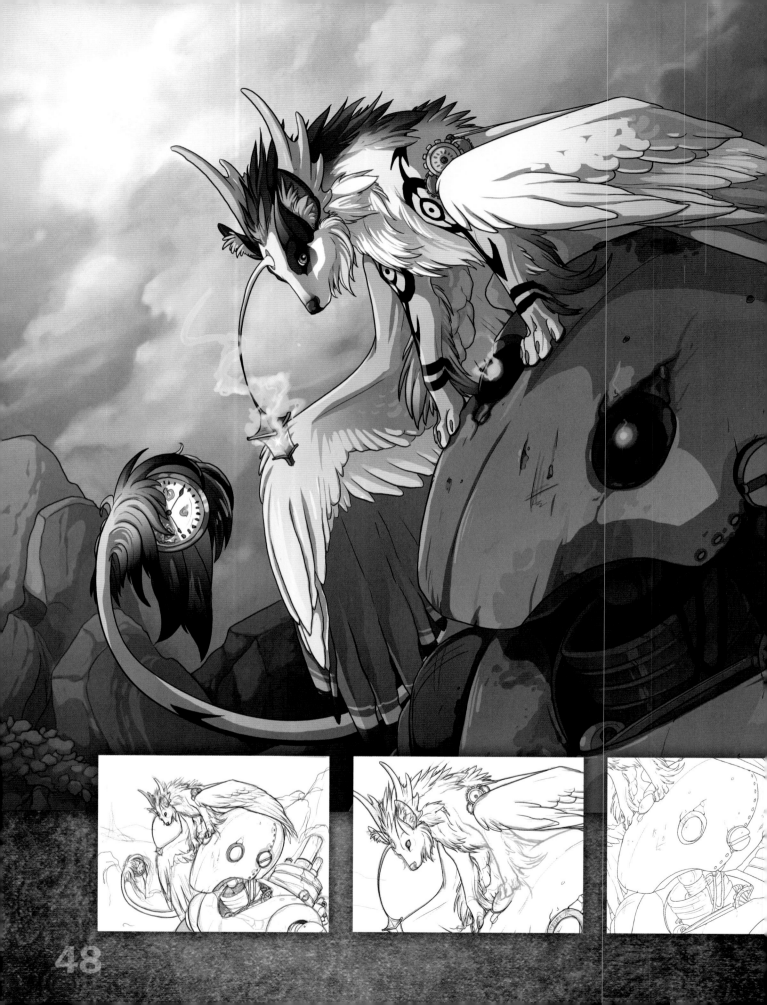

METAL AND STONE

This was a commissioned work for Sara C. of her winged, wolflike creature. I noticed that her creature had some gears and metalwork incorporated into its design, so I decided to pair it with a massive, rusted golem, who is also made of metal.

I created a rough thumbnail to decide on the general idea and composition for the image.

Using the thumbnail as a guide, I sketched in more of the details of the image, going through a first pass in red and a second pass to tighten it up in grays.

I began inking the image on its own layer in Photoshop. I used a layer effect to tint the sketchy drawing of the image in red so it was easier to differentiate between the black ink lines and the lines of my sketch. Then I created a clean inking for the entirety of the image.

For the background, I kept the clouds nice and soft, but gave some of the closer background objects, such as the rocks, linework and cel shading to go better with the foreground elements.

I painted in the flat colors (the local color without lighting applied) of the foreground objects.

I created a multiply layer above my base colors and painted in warm, cel-like shadows on the foreground elements.

I was having some difficulty with the red and yellow of the wolf being a bit jarring in comparison to the rest of the image. I made them a bit less vibrant and tried to shade them with similar warm shadows to bring the color scheme together.

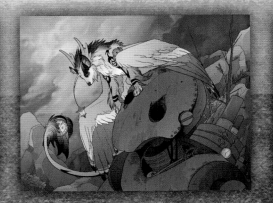

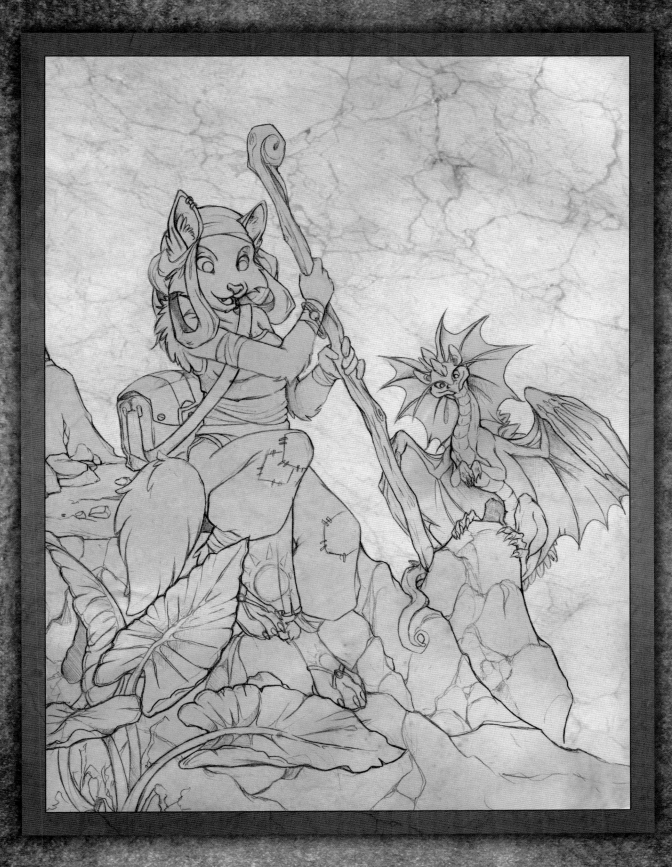

RAZIEL AND TRESH

Summer nights.

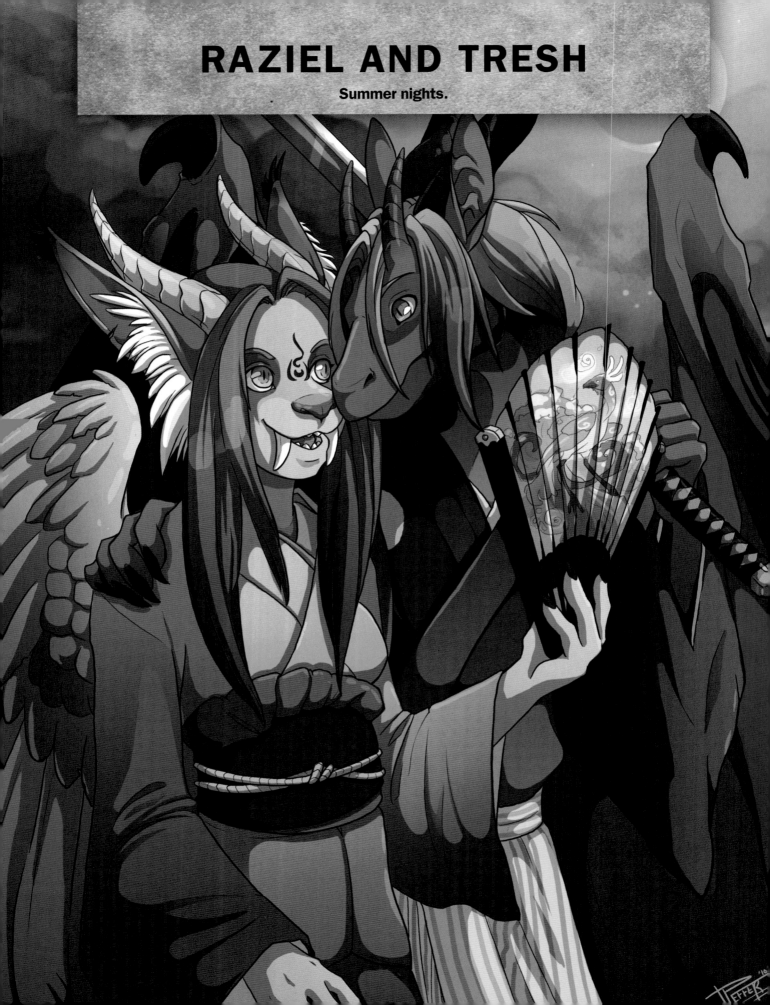

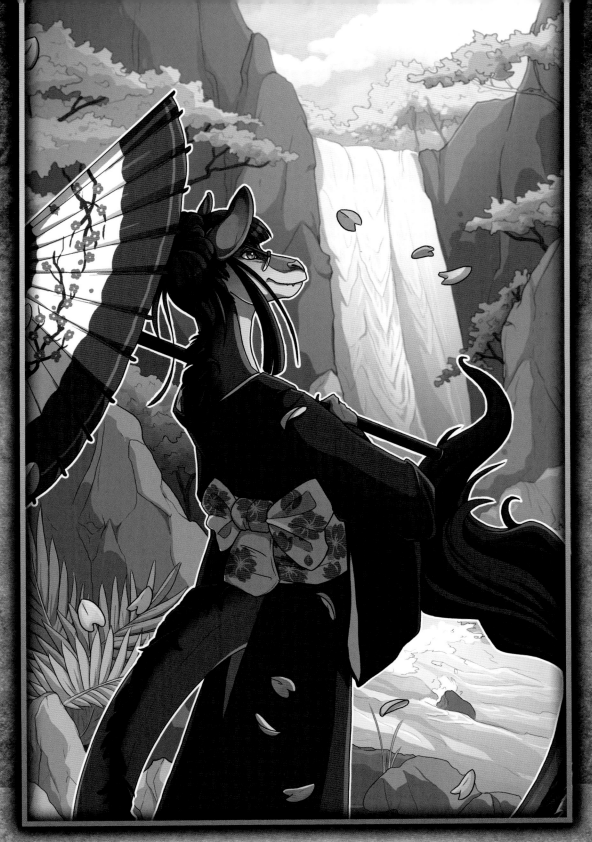

AMELYCE

Caedere's Amelyce enjoys the cherry blossoms in bloom.

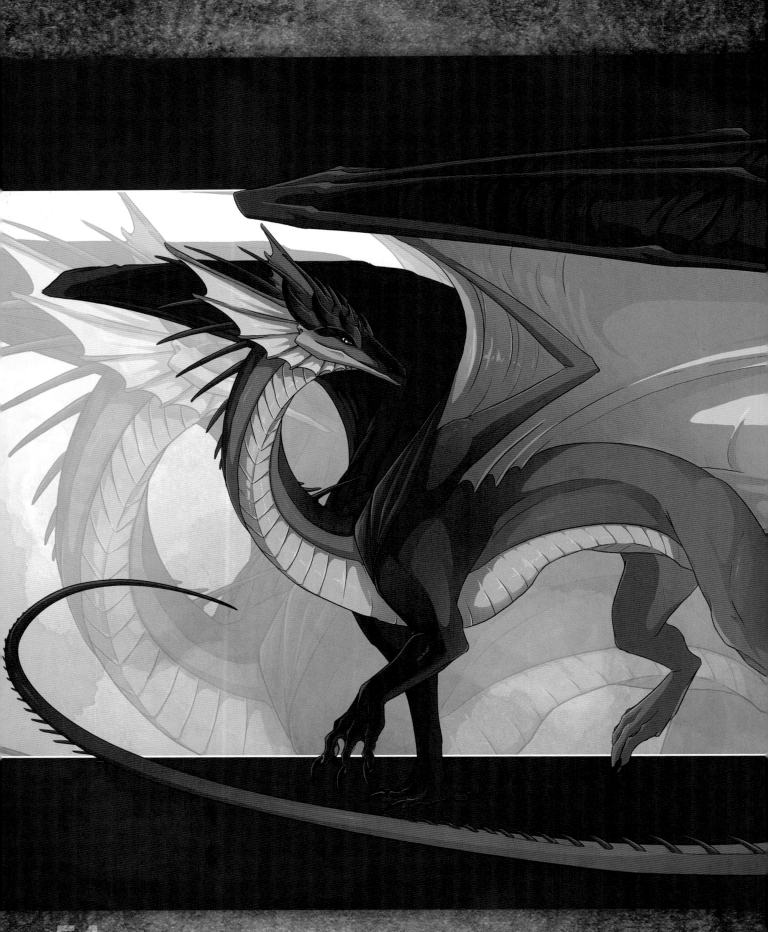

RILRAE

THE DEEP GREEN

This image was a commissioned piece of Dragonap's Ivadun creature. I started the image by creating a loose thumbnail to help me decide on the composition and colors I wanted to use. Using a hard, round brush at 70 percent opacity, I drew a more refined sketch, putting in some of the details. I blocked out the foreground and began to paint the background in black and white, establishing the value structure. After I was finished with the black-and-white background, I added color to the environment.

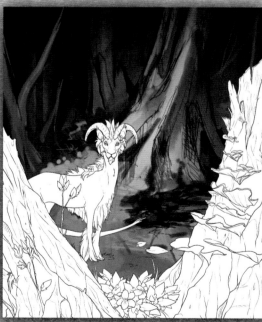

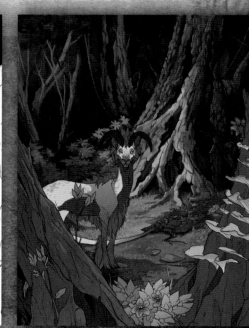

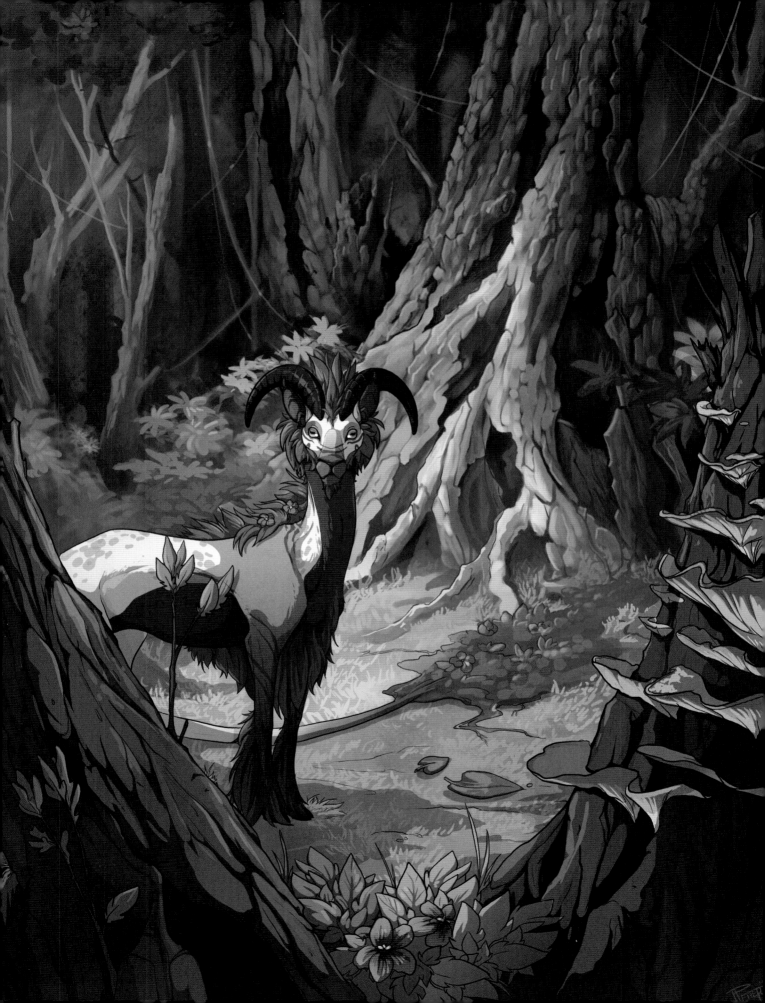

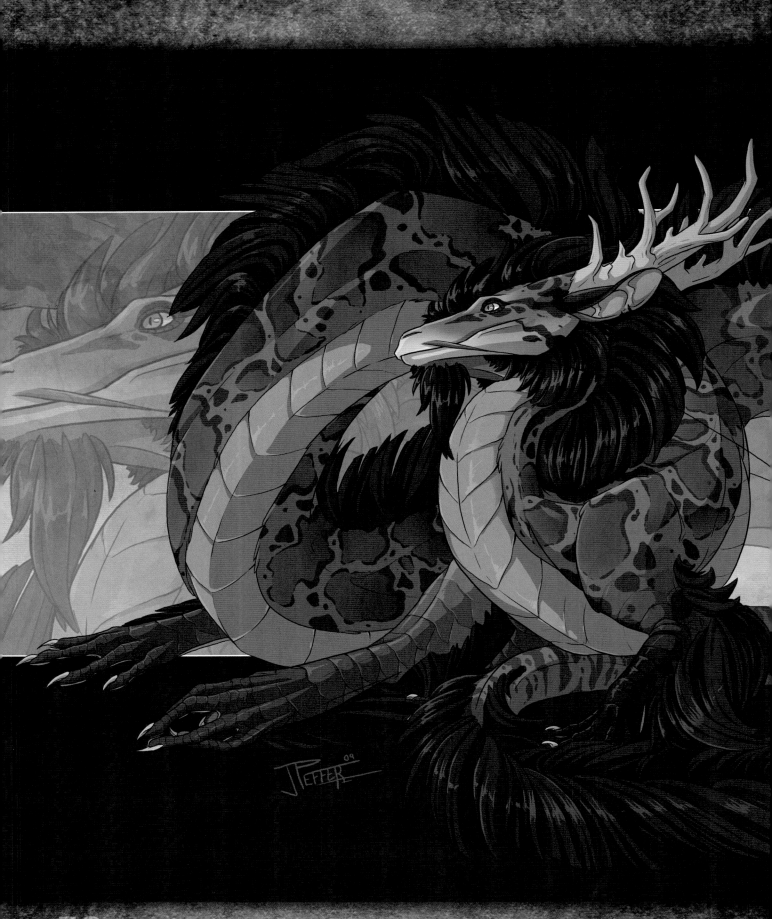

LUNG KNOT

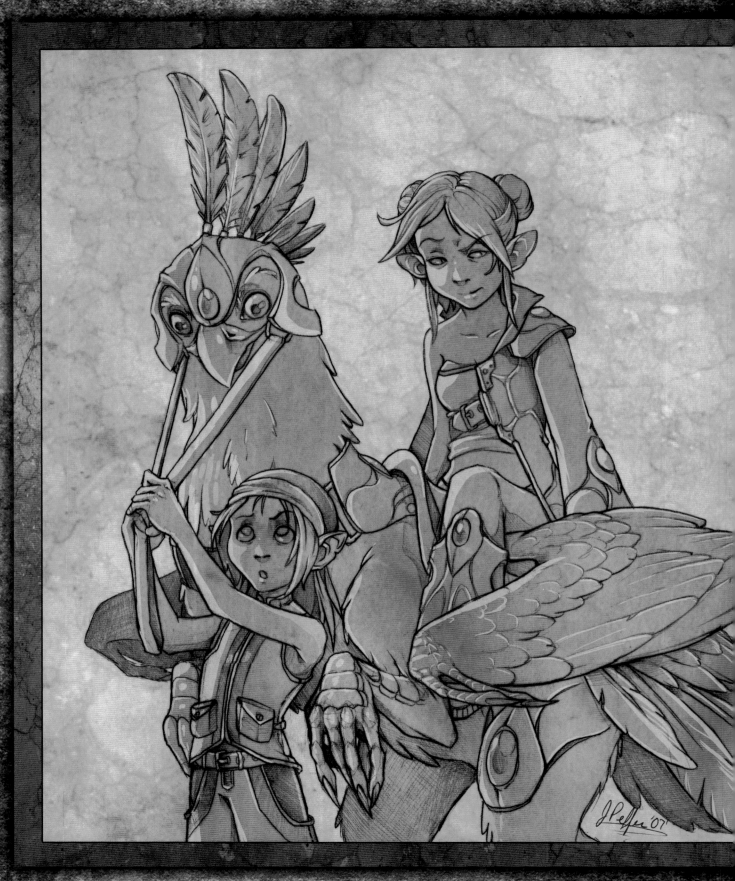

AIR

Bird Rider

WHITE GRYPHON

I drew this delicate gryphon on my drawing pad using a 4H mechanical pencil. I liked the drawing, so I wanted to create a colored version digitally, but I did not want to lose the quality and texture of the original pencil drawing.

I painted in a set of slightly varying off-white flats, then applied a digital texture (courtesy of the artist hibbary) over the drawing to give it a watercolored look. On a new layer, I painted in a few select highlights.

HIPPOGRIFF

The hippogriff is a creature born of a gryphon and a mare. Because a mare is generally regarded as prey by the gryphon, a hippogriff is truly a creature born from love.

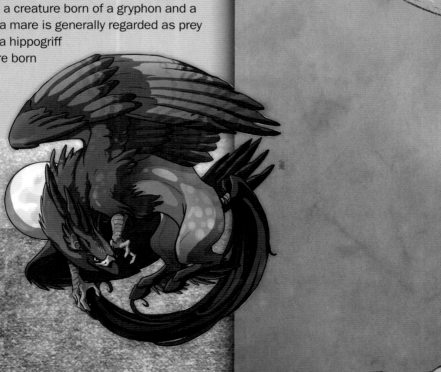

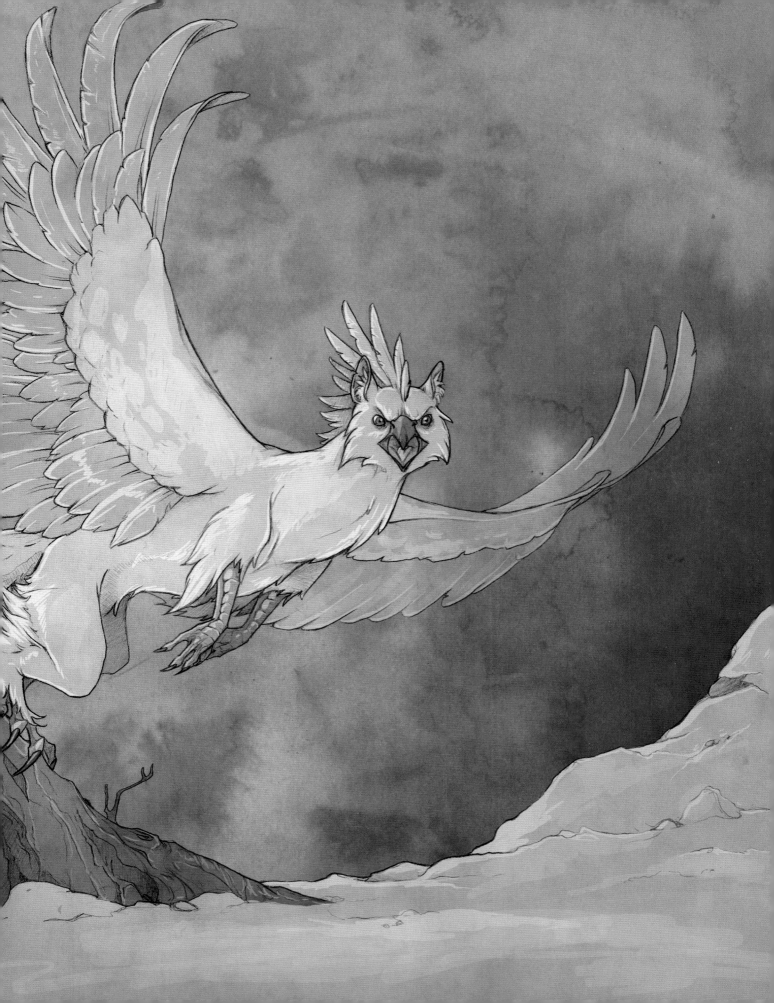

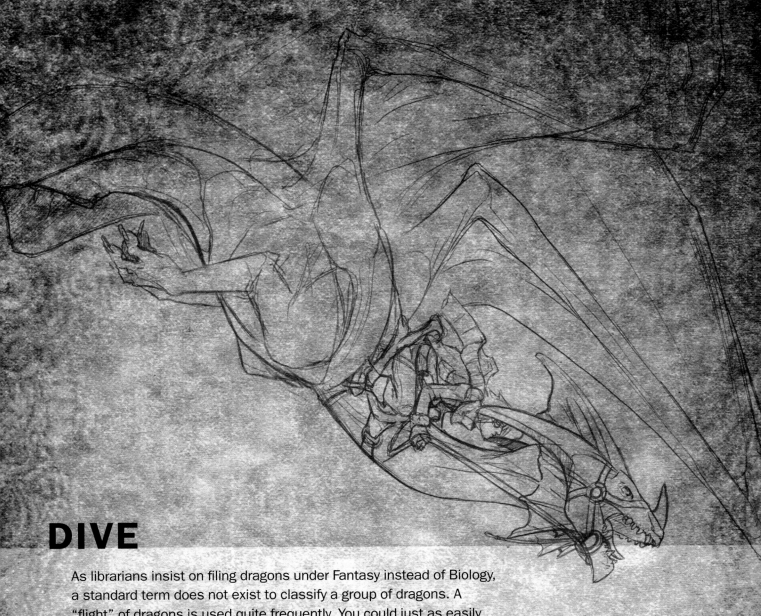

DIVE

As librarians insist on filing dragons under Fantasy instead of Biology, a standard term does not exist to classify a group of dragons. A "flight" of dragons is used quite frequently. You could just as easily use "wing" if your story is more military-focused, or a "swarm" of dragons if they form massive groups. "Pack," "clan" and "flock" have all been used at one time or another to label a grouping.

If you're stuck on what to call your group of dragons, think about the world that you've imagined, and choose a term you think best suits the people, culture and role of the dragons in that world.

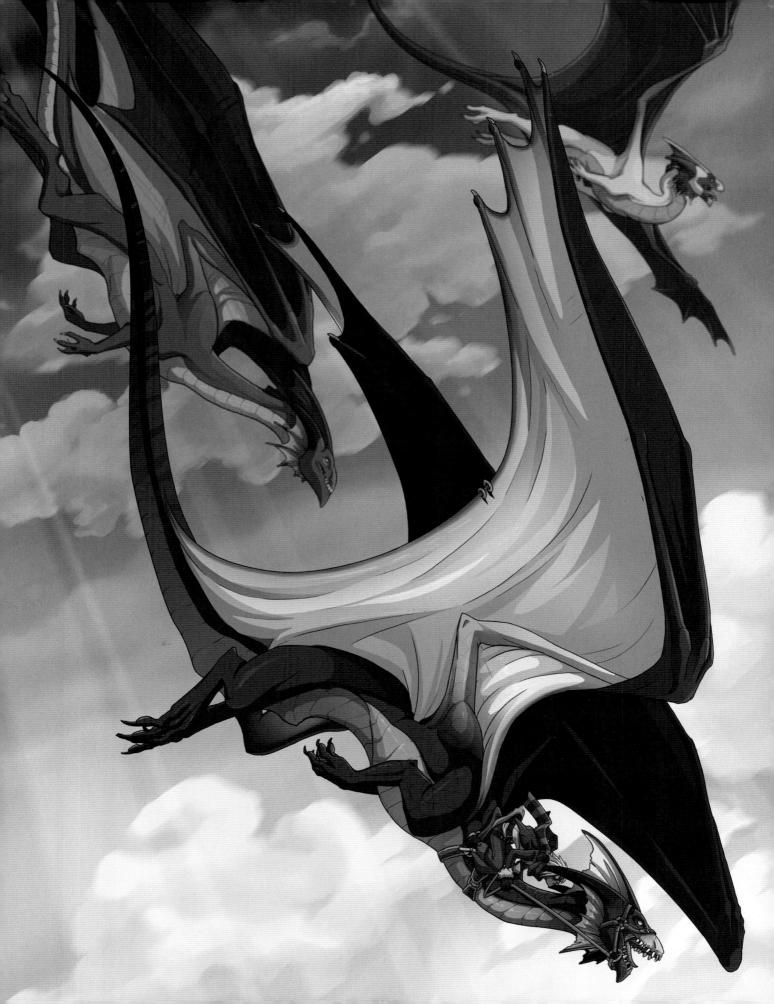

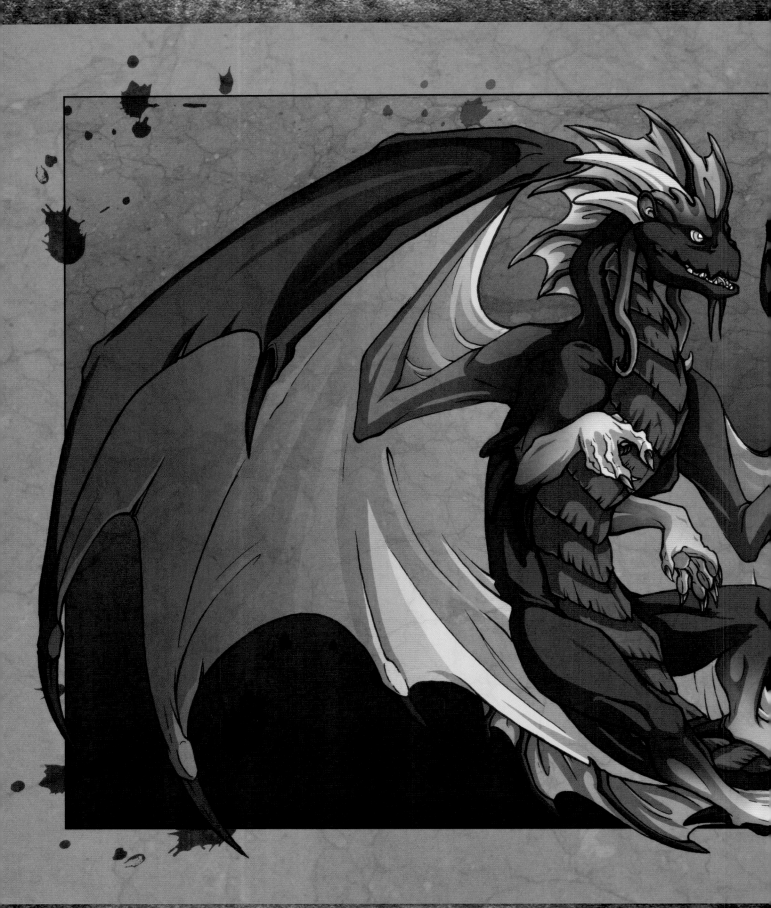

DOOFY
DRAGON

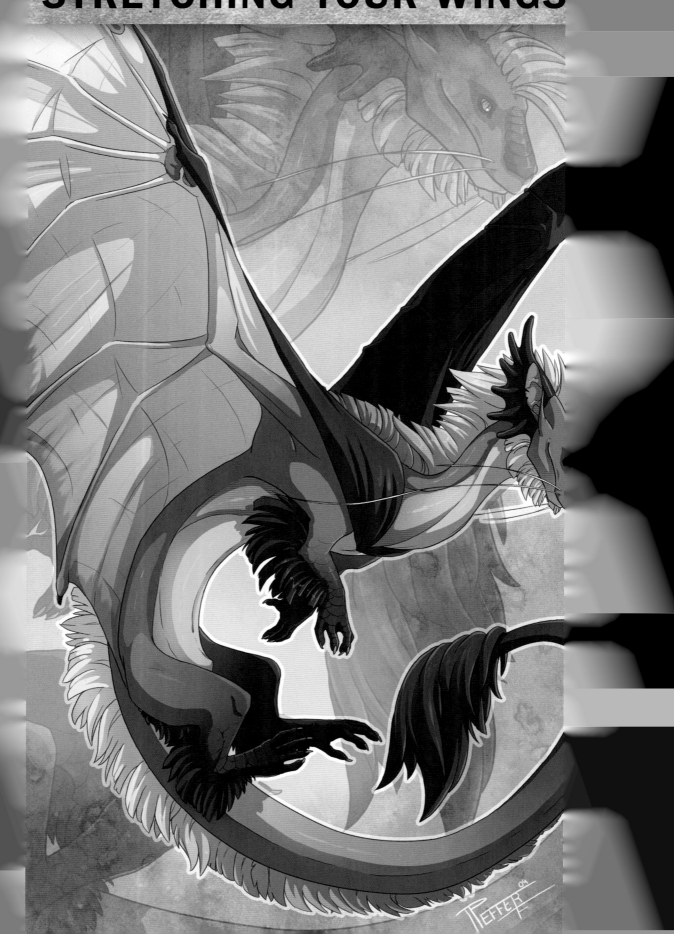

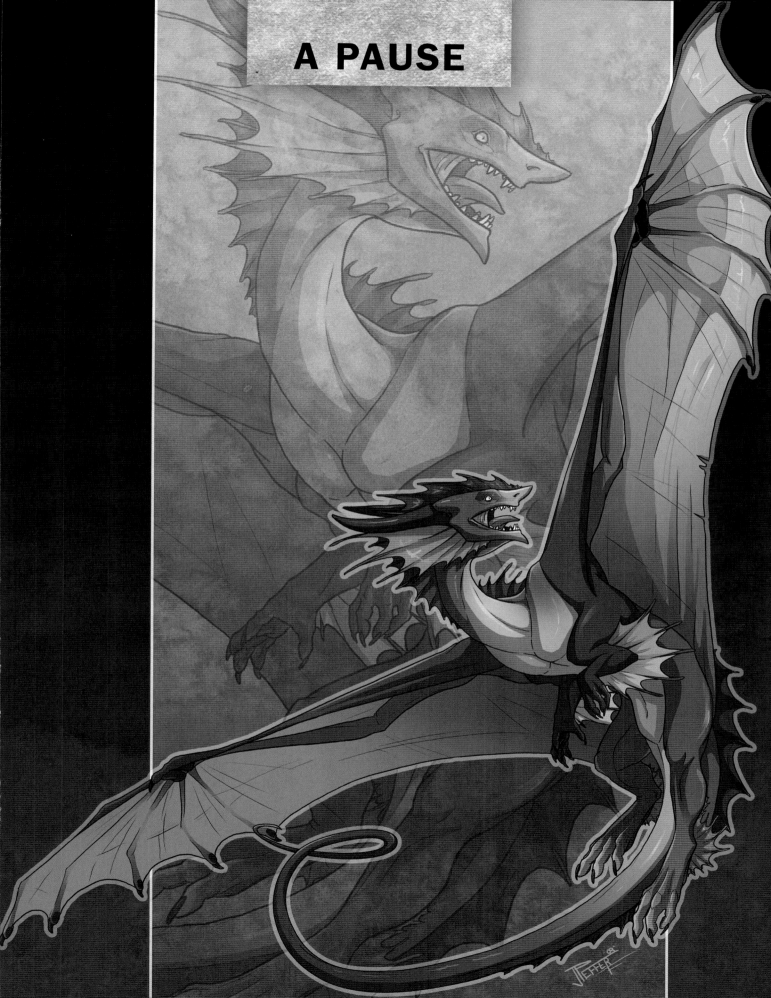

A PAUSE

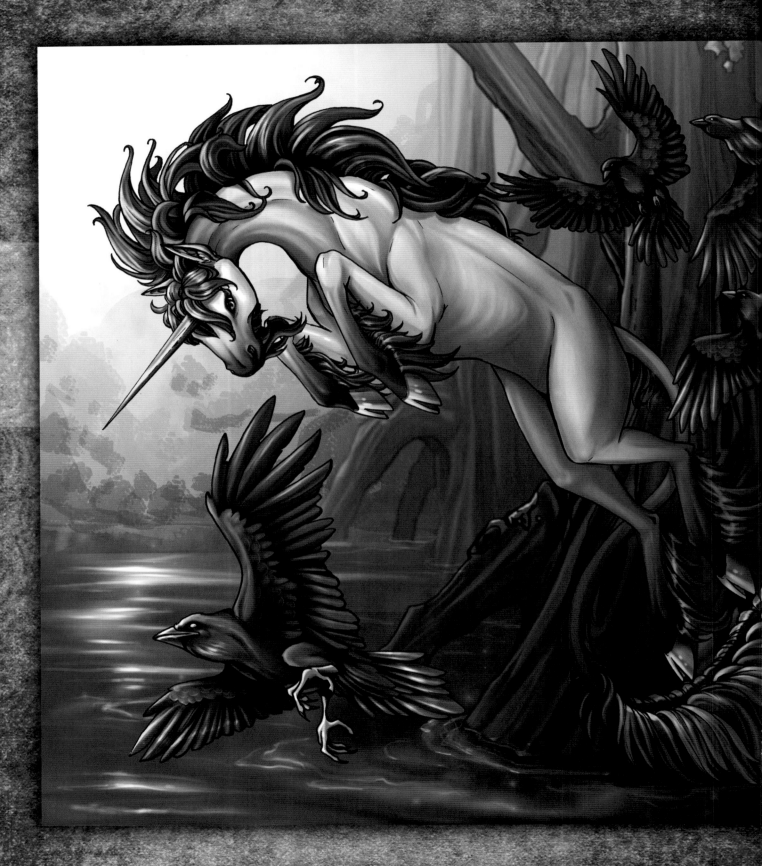

SPIRIT SOARING

DAYDREAM

This image began as a bit of doodling fun. I was drawing with the idea of creating a Nightmare-like (demon horse) creature. He later gained a friend and I decided he really couldn't be all that terrifying; I don't think he'd have nearly so adorable a follower if he were truly evil.

I scanned the pencil work into the computer and painted the rest of the image digitally. Rather than color it the typical black and red of such creatures, I decided that white and blue would be a bit more whimsical. What was once a flaming mane simply became an unruly one made of nothing more than hair.

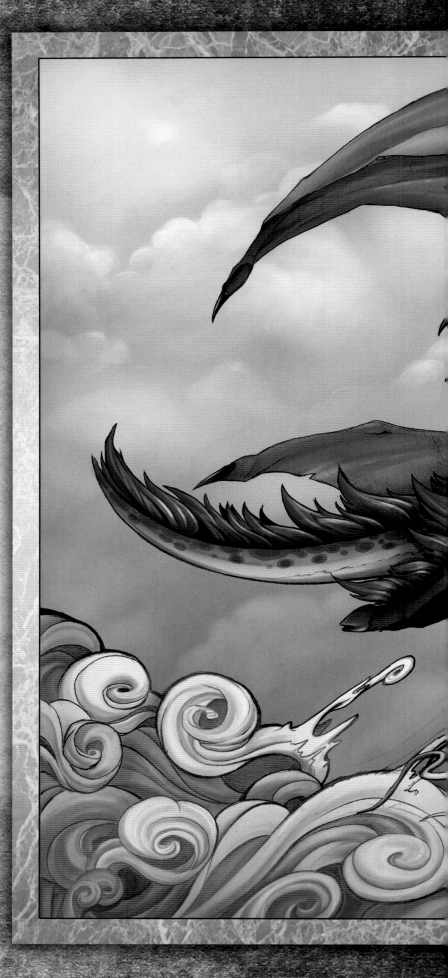

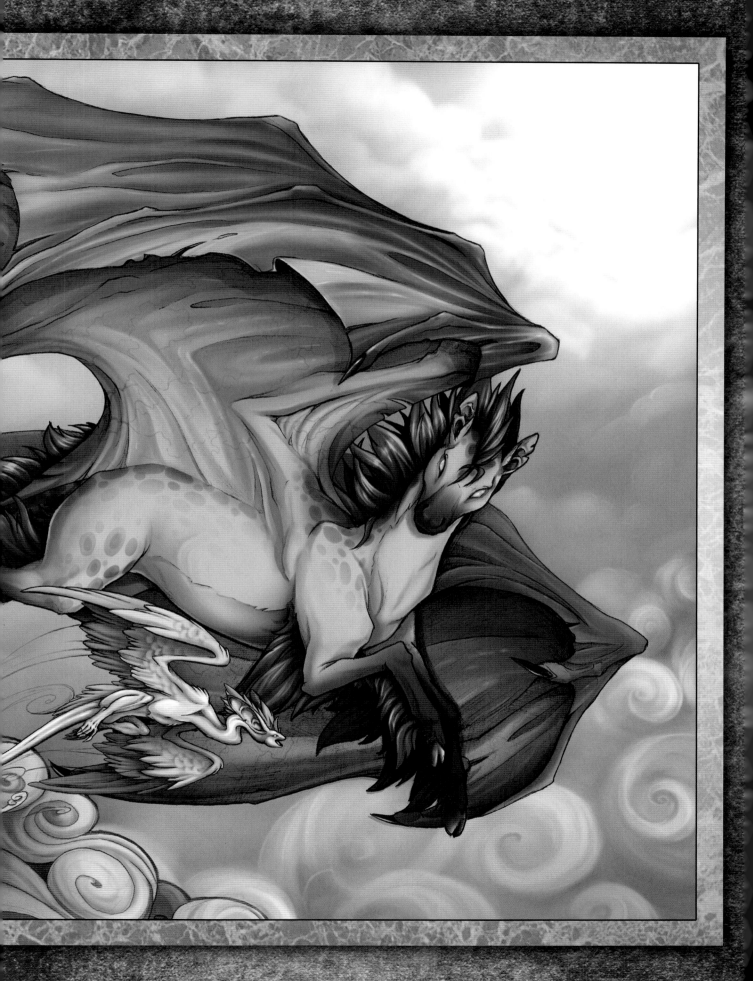

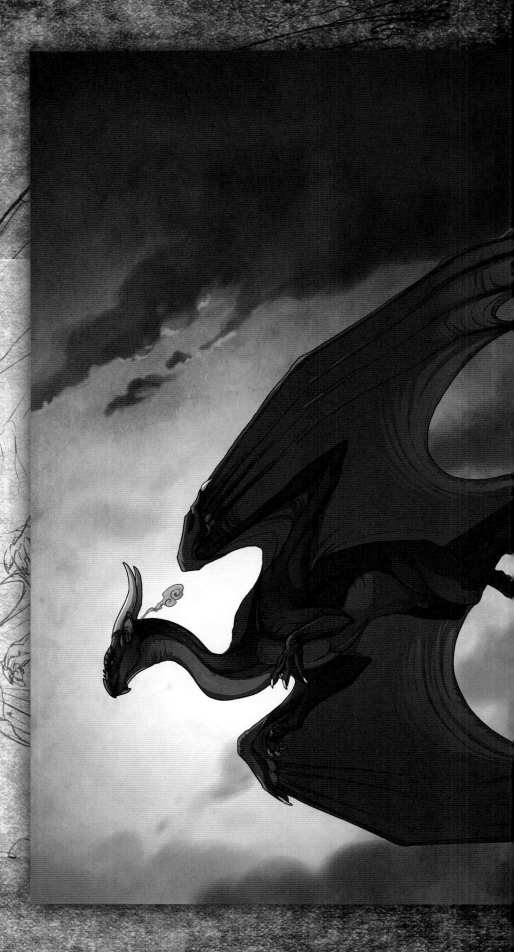

CLOUD
KEEPER

This was an image commissioned by Whiro of his dragon playing among the clouds.

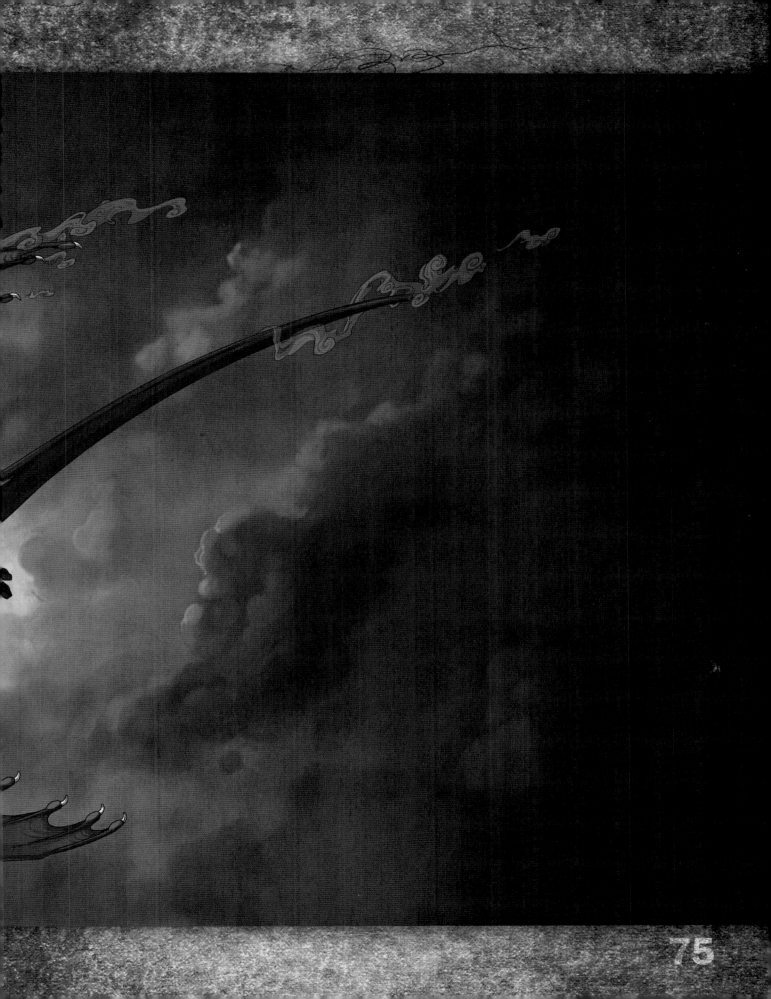

MYNZAEA

This image was commissioned by Hannah P. She had a rough idea of some of the elements she wanted included in her design, but since she hadn't ever commissioned an image of her dragon before, I wanted to make sure she liked where I was going with the image. Thumbnails are always an excellent idea!

After Hannah approved the thumbnail, I created a digital drawing of the artwork using the thumbnail as a guide.

I inked the dragon using a 4-pixel hard, round brush in Photoshop. I then painted a warm sunset sky behind the dragon.

The flat colors of the dragon included some gradient transitions and patterning.

I like the comic-book feel that breaking the character outside the lines provided.

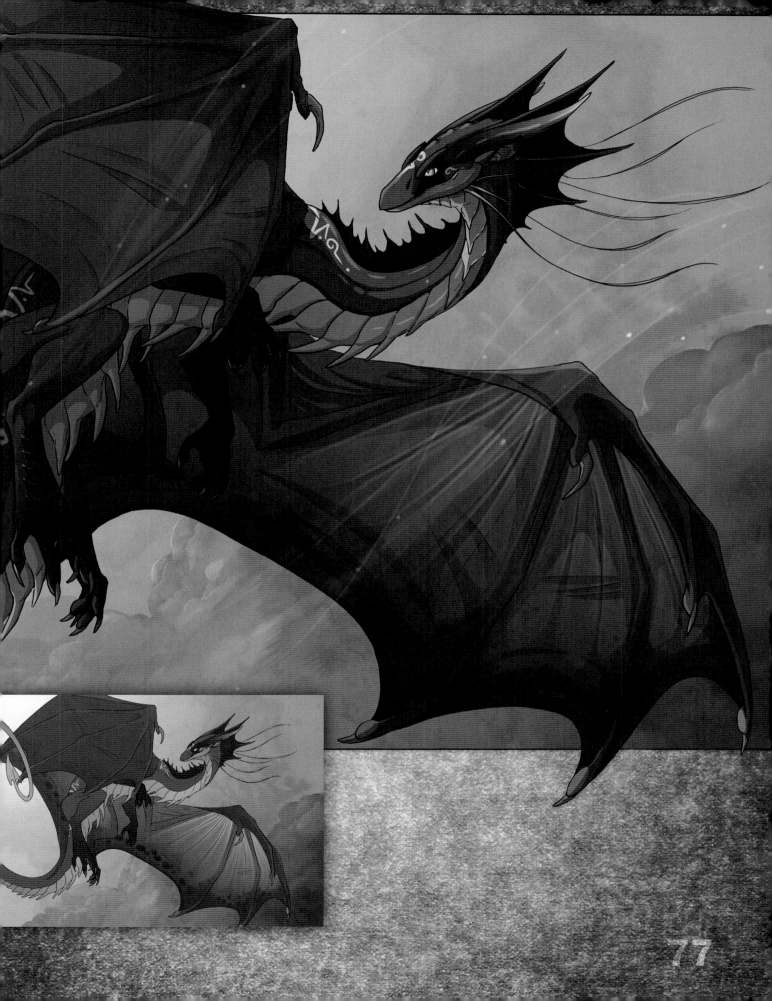

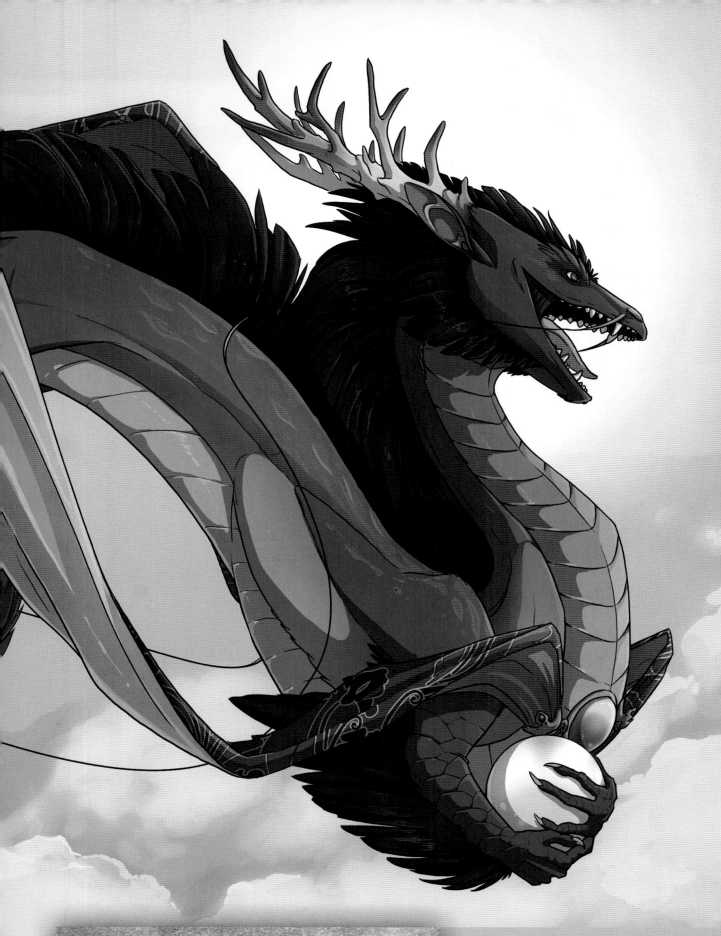

EASTERN FLAIR

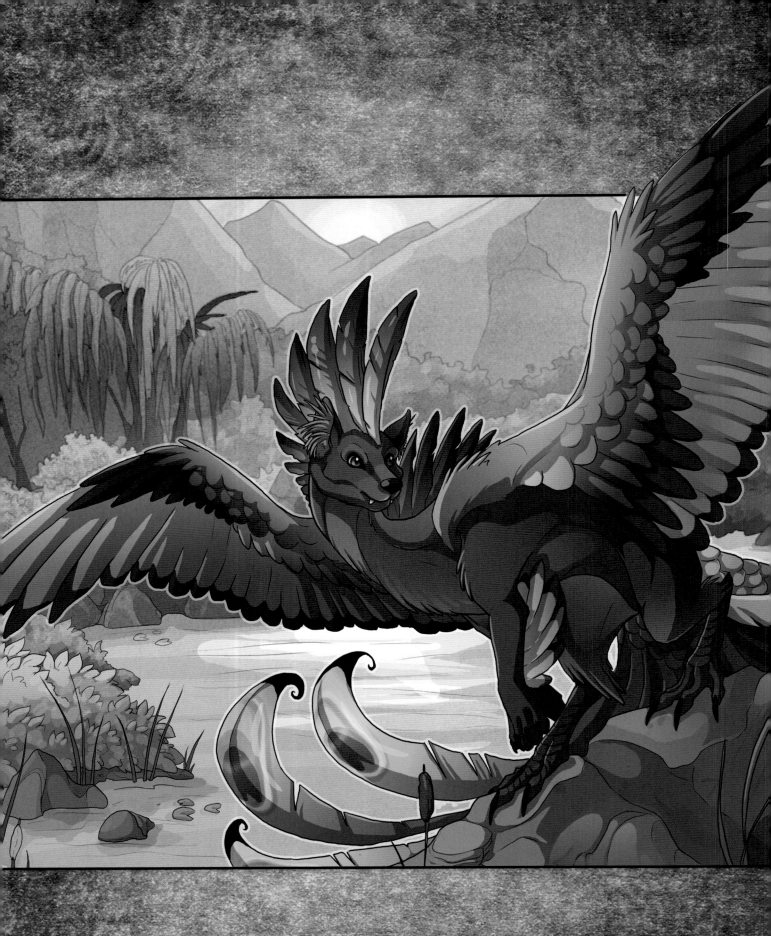

ANGHA

DRAGONRIDER

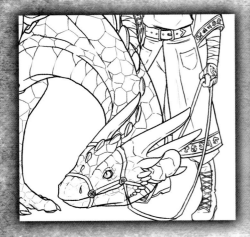 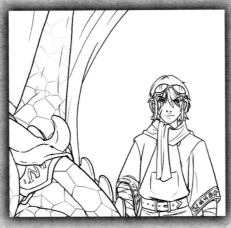

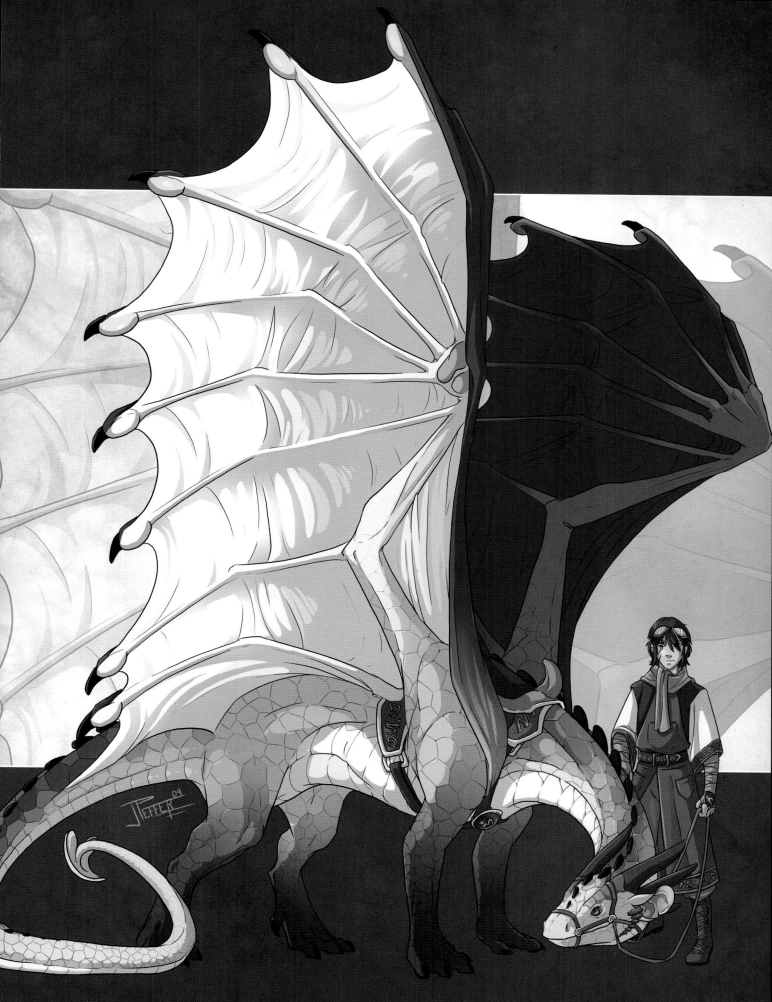

OMNIBAHAMUT

The name of this dragon was the same as the online alias of the spiffy person who commissioned it.

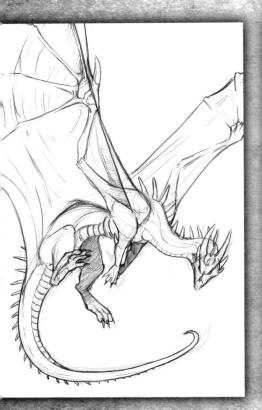

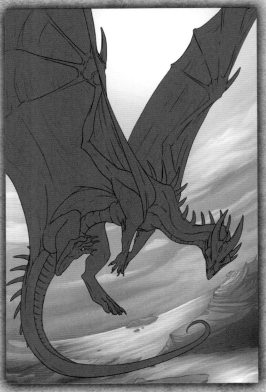

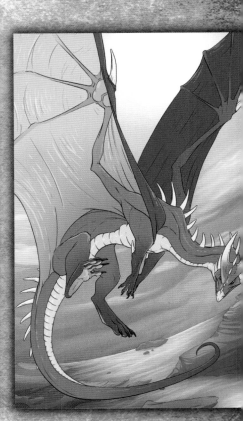

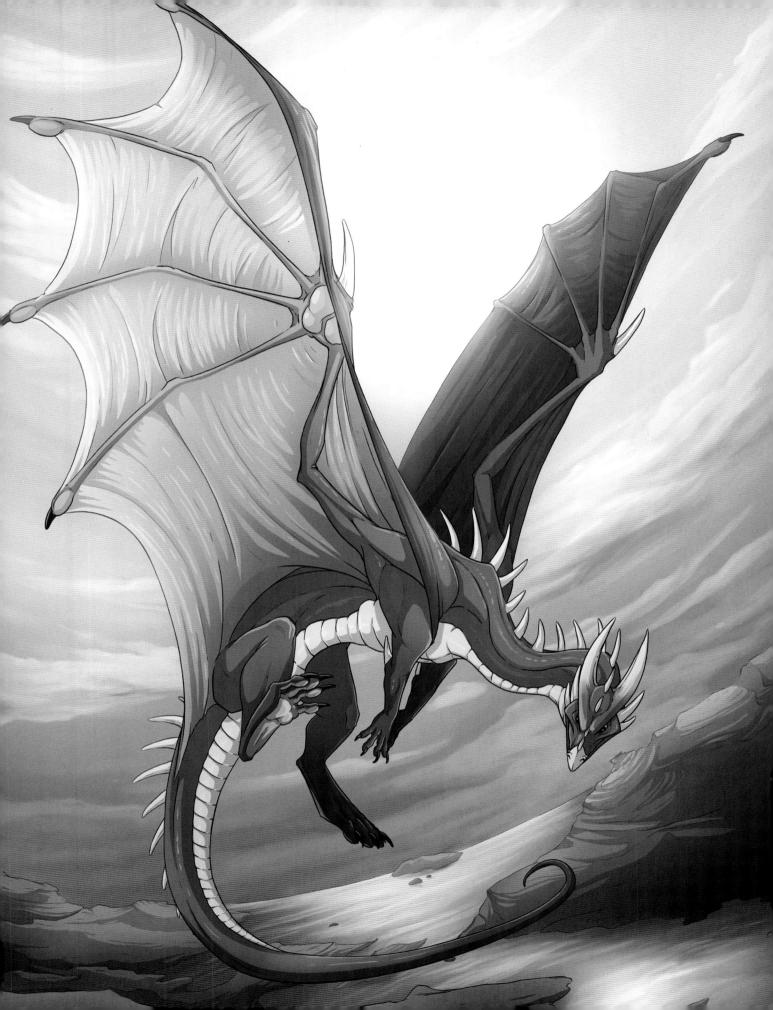

DESIGNING DRAGONS

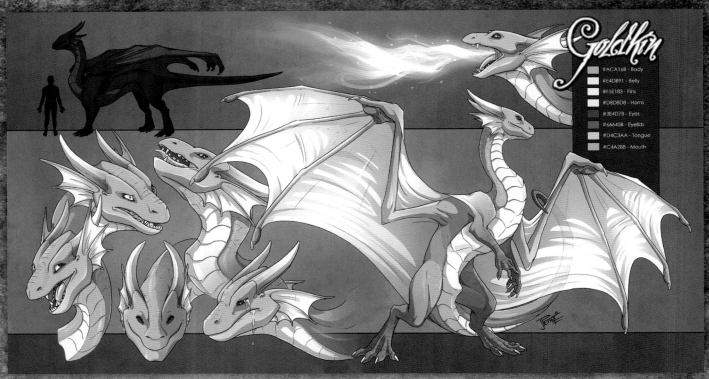

This was a commissioned piece for Goldkin of their dragon.

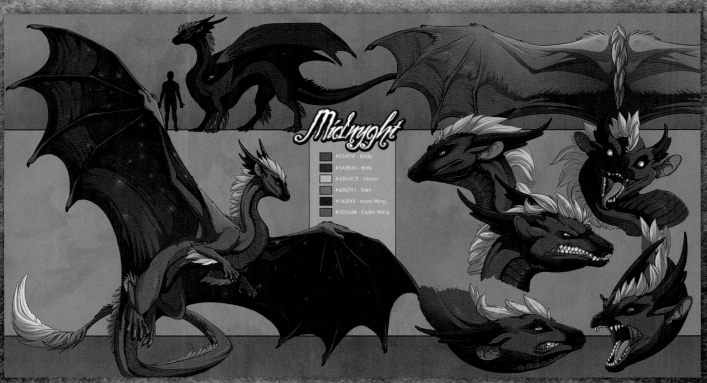

This was a commissioned piece for Anya of Midnyght, her black dragon, a cross between an Eastern and a Western dragon.

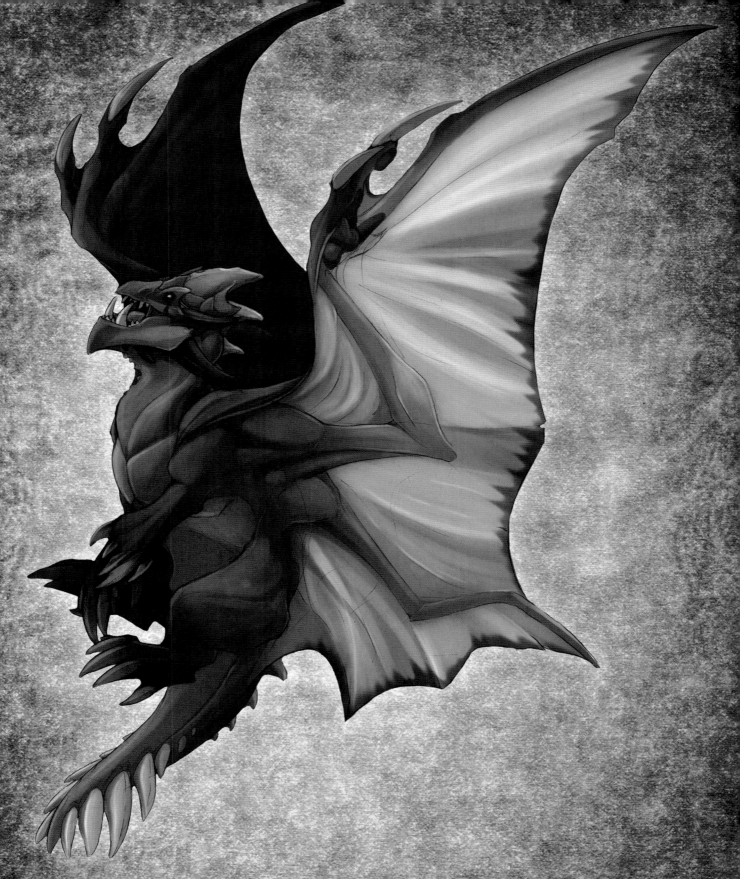

THUNDERHEAD DRAKE

DRAKE

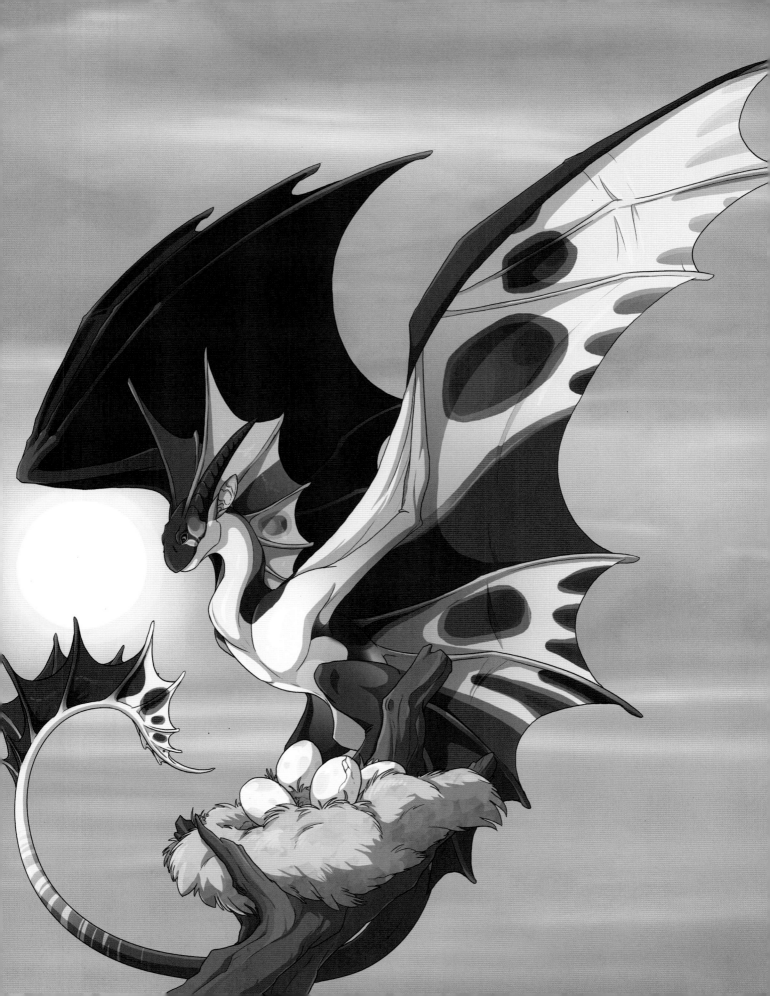

MIRROR DRAGONS

Mirror dragons are ravenous, feral creatures that consume their body weight in meat every month. Their four eyes serve two purposes: the larger back set allows them to see light, while the smaller front set allows them to see heat as they hunt. Mirror dragons are migratory hunters that run in large packs. After they deplete prey in one territory, they move on to the next. Other dragons view them as a nuisance.

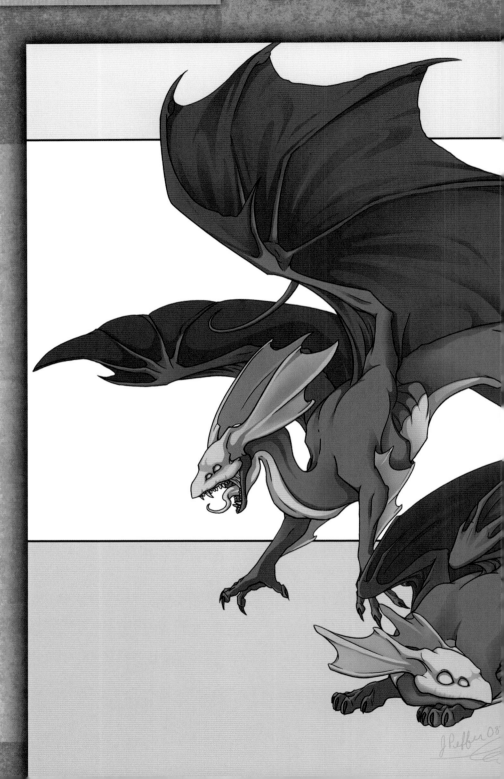

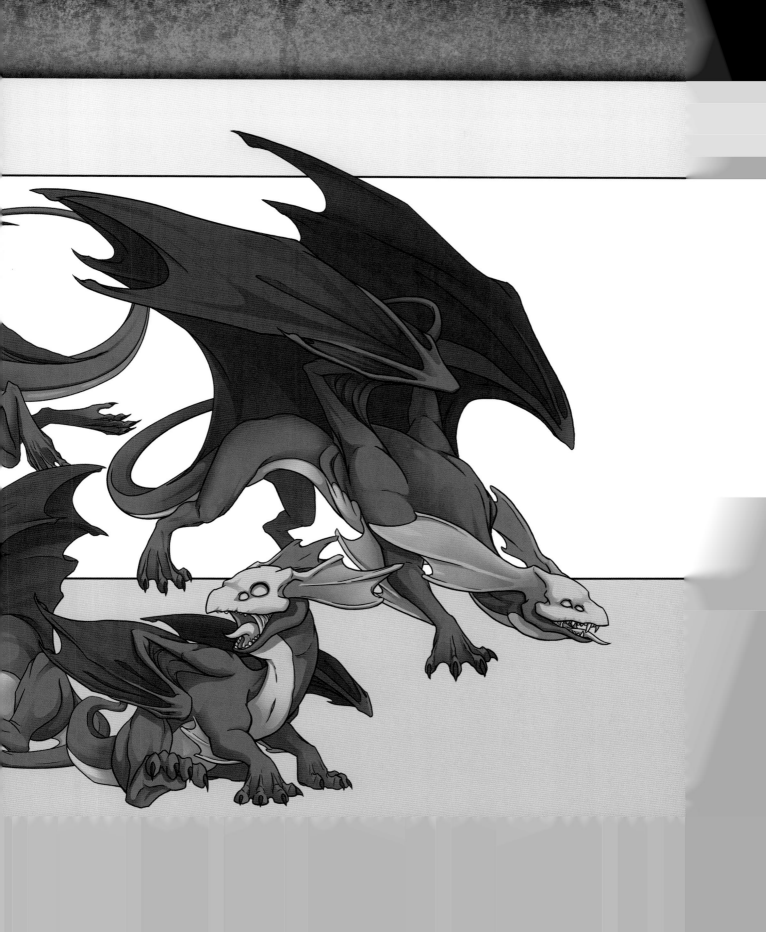

FAE DRAGONS

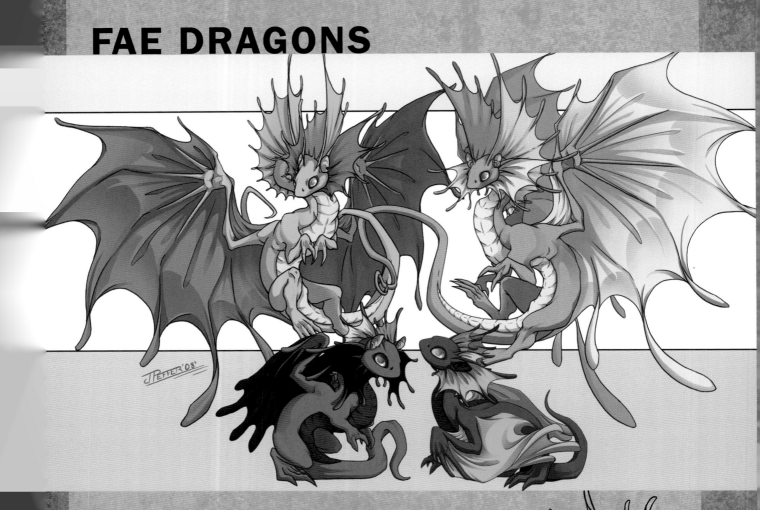

Fae dragons are small, highly active creatures. They live in massive colonies with populations that number in the tens of thousands. Fae dragons spin their homes of tree sap that they have cured with magic to become a beautiful golden amber. Their colonies are built on the sides of sheer cliffs or the trunks of massive trees, far out of the reach of other predators. Older colonies often meet catastrophic ends when the weight of too many dens takes down the cliff side or tree.

GUARDIAN DRAGONS

Guardian dragons are true to their names. Upon coming of age and leaving their nests, fledglings seek out a worthy person, treasure or location to stand watch over for the remainder of their considerable lives. Guardian dragons see the failure to keep their chosen charge safe as a terrible blight to their honor, and most will pine away rather than live with the shame of their failure.

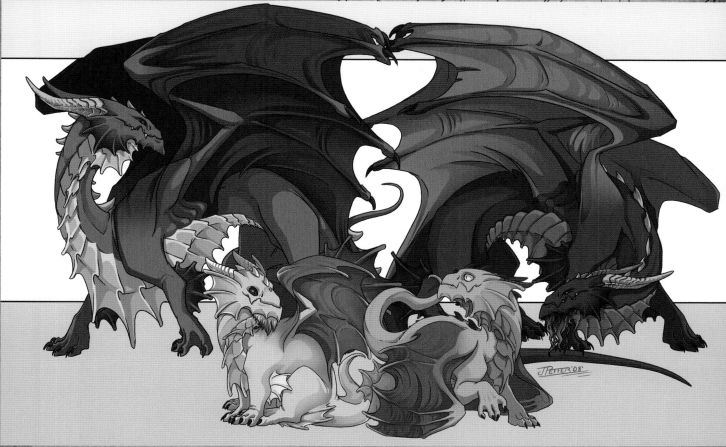

RIDGEBACK DRAGONS

Easy-going ridgeback dragons are covered in long spines. These dragons live in small family groups that they spend the rest of their lives with. Ridgeback dragons rarely venture out into the world. On the rare occasions when they encounter a stranger, they try their best to be friendly, inviting the individual to stop and fish. The freshness of the fish may be a question worth asking, though.

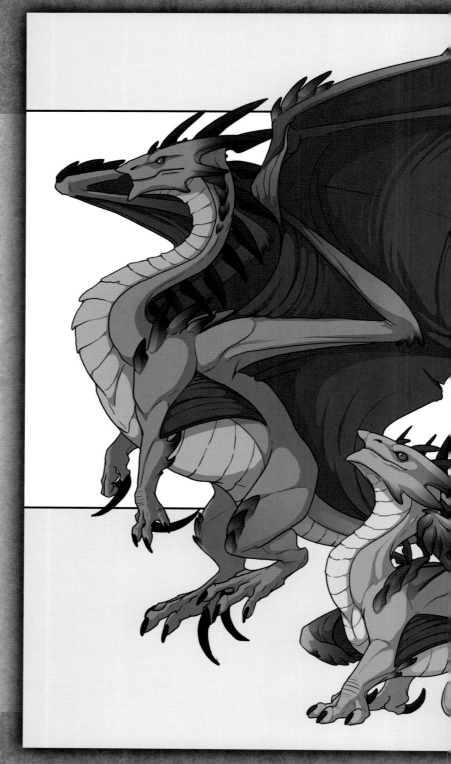

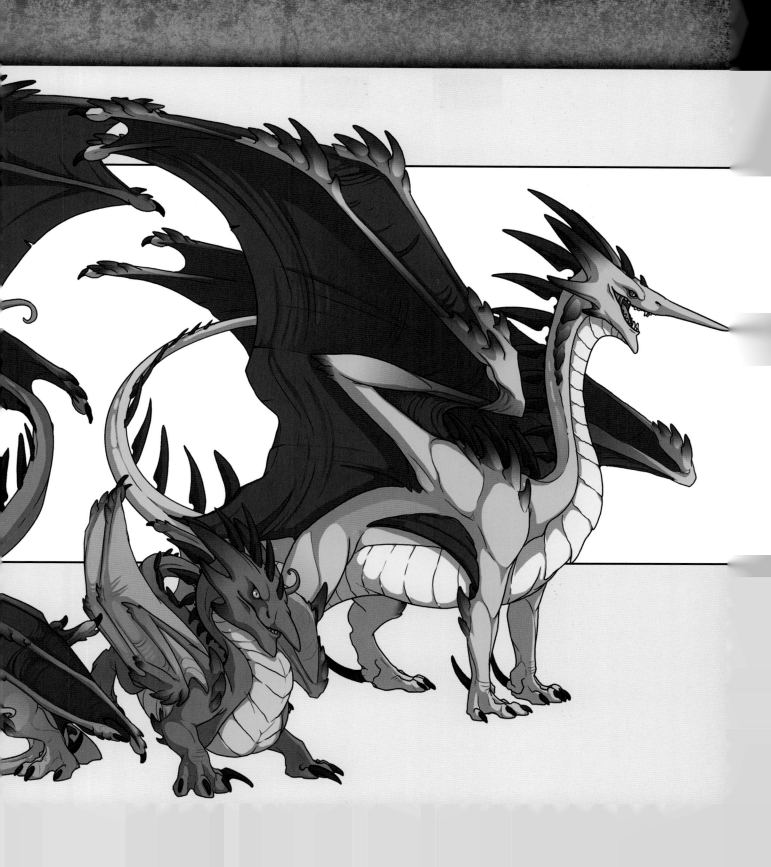

TUNDRA DRAGONS

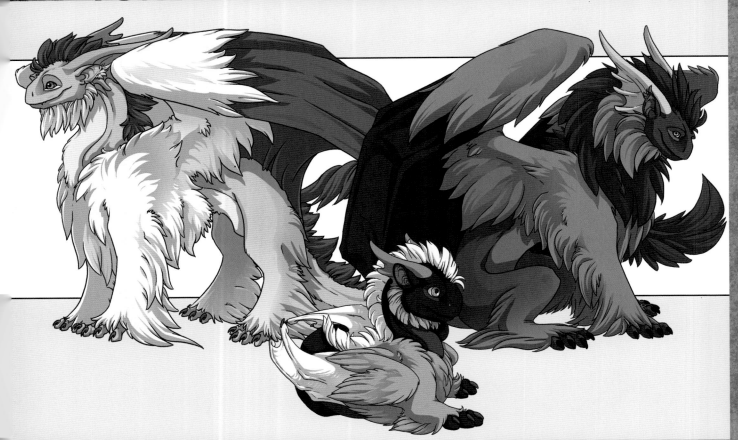

The gentle tundra dragons are covered in thick, coarse fur. Tundra dragons are not the brightest of creatures. They survive by virtue of their toughness and their ability to eat almost anything. This allows them to have uncontested domain over harsh, barren tracts of land that other dragons are pleased to avoid. Tundra dragons are generally friendly, if lacking in manners.

PEARL CATCHER DRAGONS

After hatching, pearl catcher dragons proceed to consume their own eggshells before their wings have finished drying. Several hours later, they regurgitate a large, lustrous pearl that they carry with them throughout their lives. They are highly protective of these pearls; if presented with the dilemma of choosing to save their eggs or save their pearl, they choose their pearl without fail.

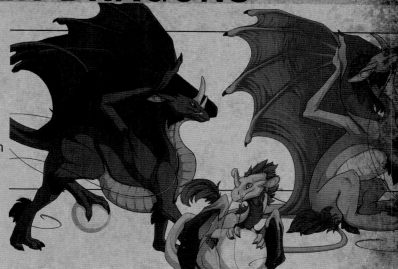

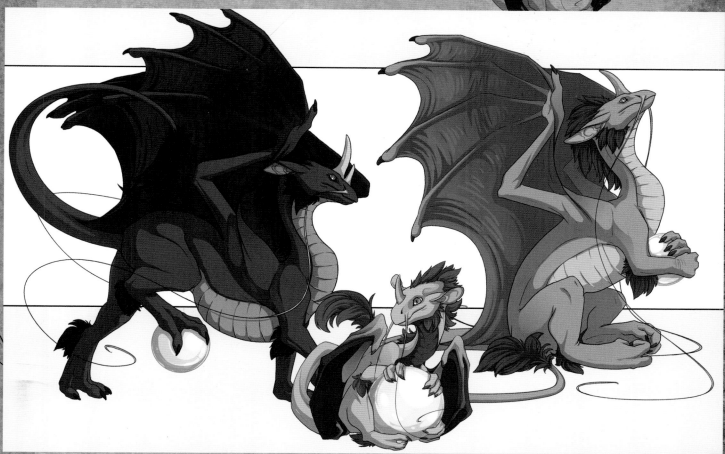

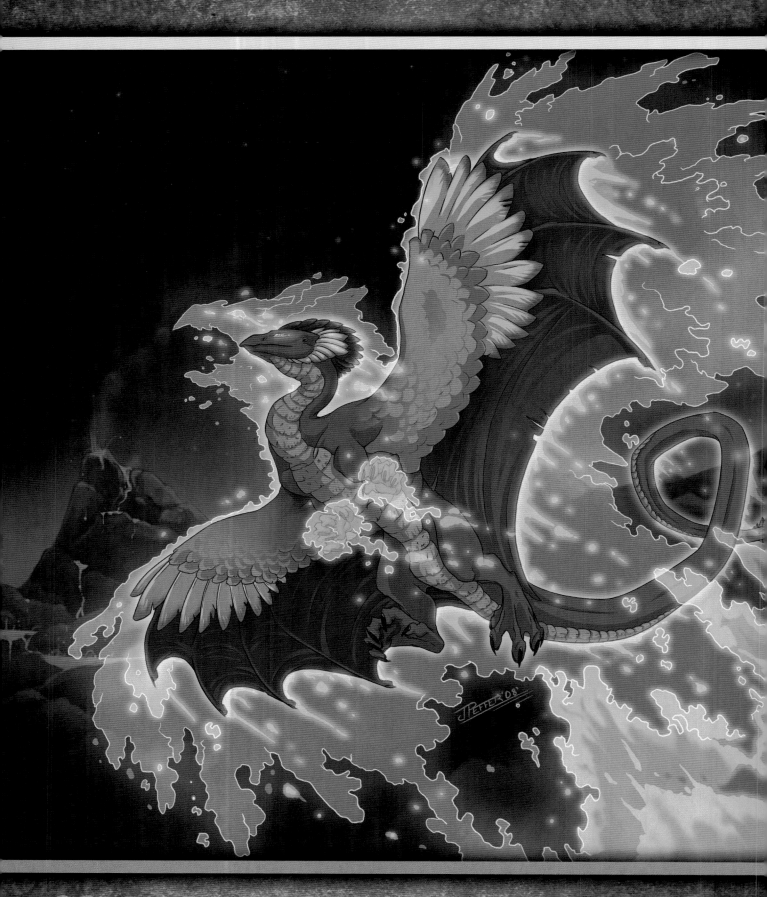

4 FIRE

The Fire Lord

PLAYING WITH FIRE

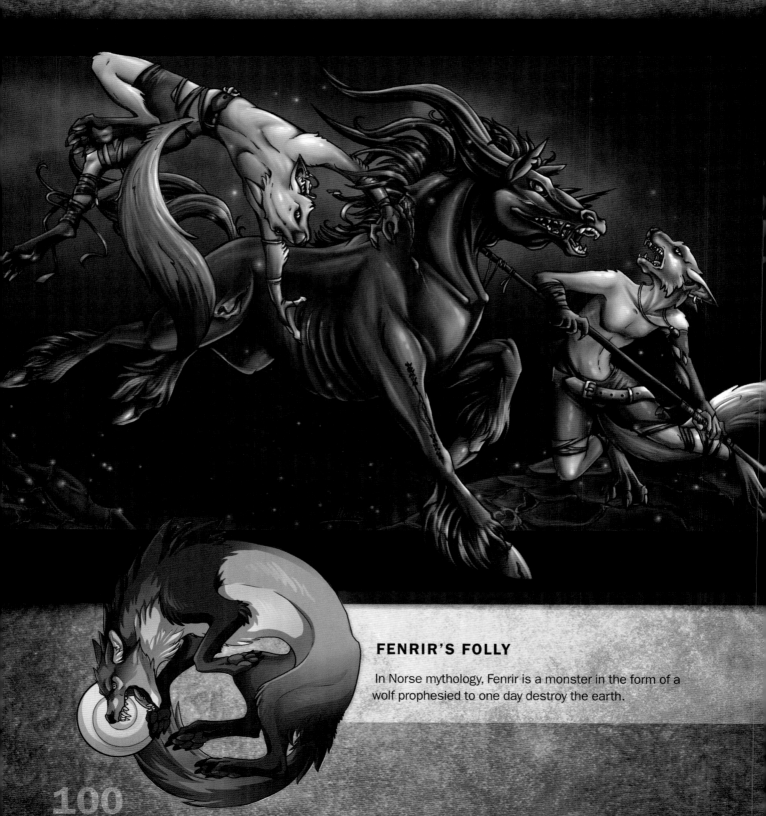

FENRIR'S FOLLY

In Norse mythology, Fenrir is a monster in the form of a wolf prophesied to one day destroy the earth.

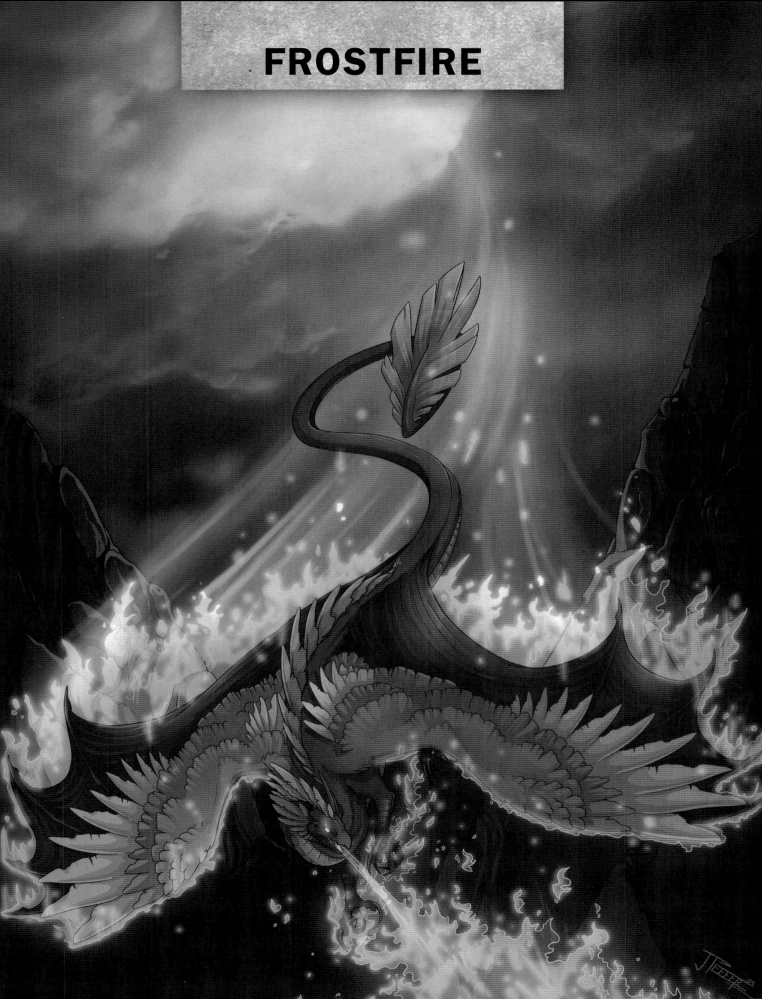

FROSTFIRE

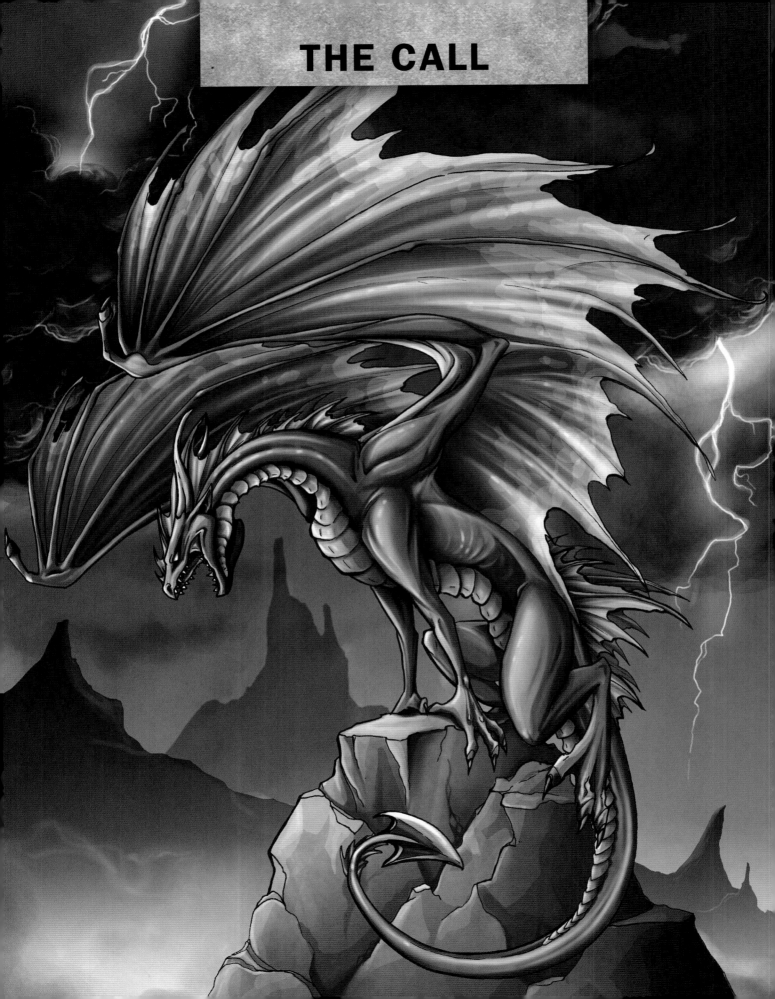

THE CALL

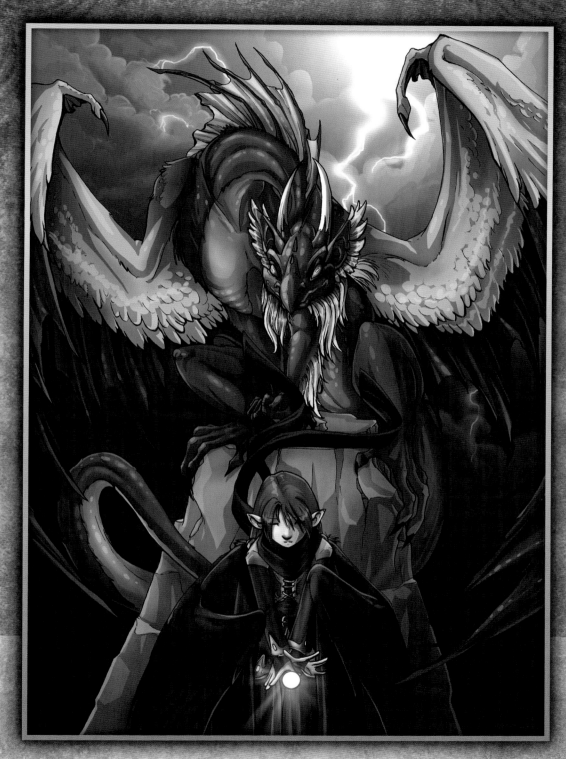

A LIGHT IN THE DARK

CINDER

I sketched a phoenix with a decorative branch and forest background using a drawing tablet and Adobe Photoshop.

Then I created a new layer above my sketch and used a hard, round brush to digitally ink the drawing, creating clean linework I could easily apply color to.

I roughed in some of the basic colors of the phoenix using a radial gradient as a starting point.

I continued to create selections among my foreground elements and filled them with gradients, painted patterns and textures. I painted the background elements with a softer-edged brush and allowed the flame element to frame the image.

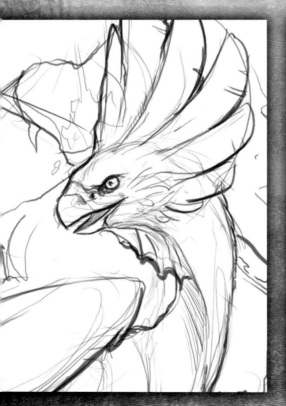
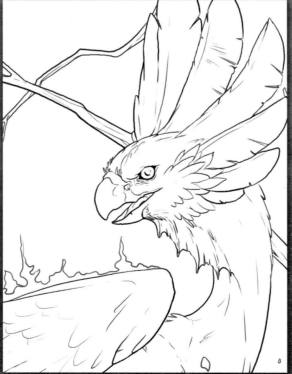

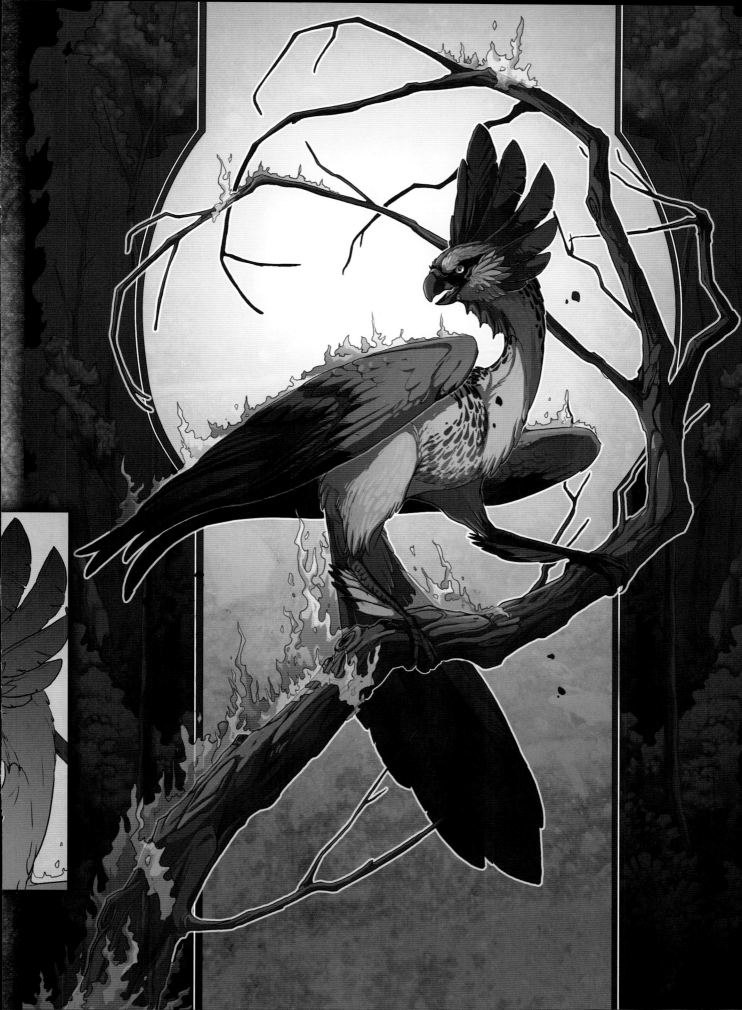

THE LAST GUARDIAN

I painted this for Earth Day.

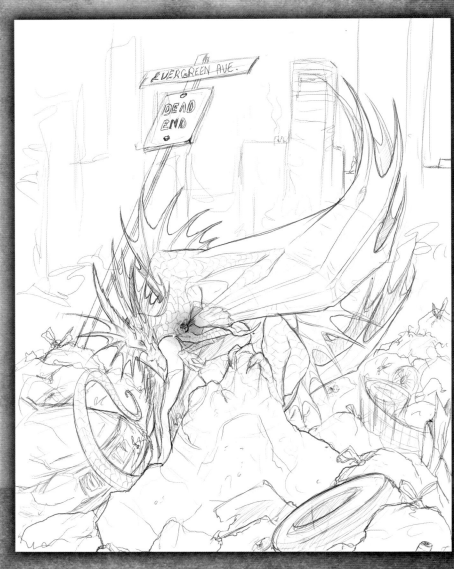

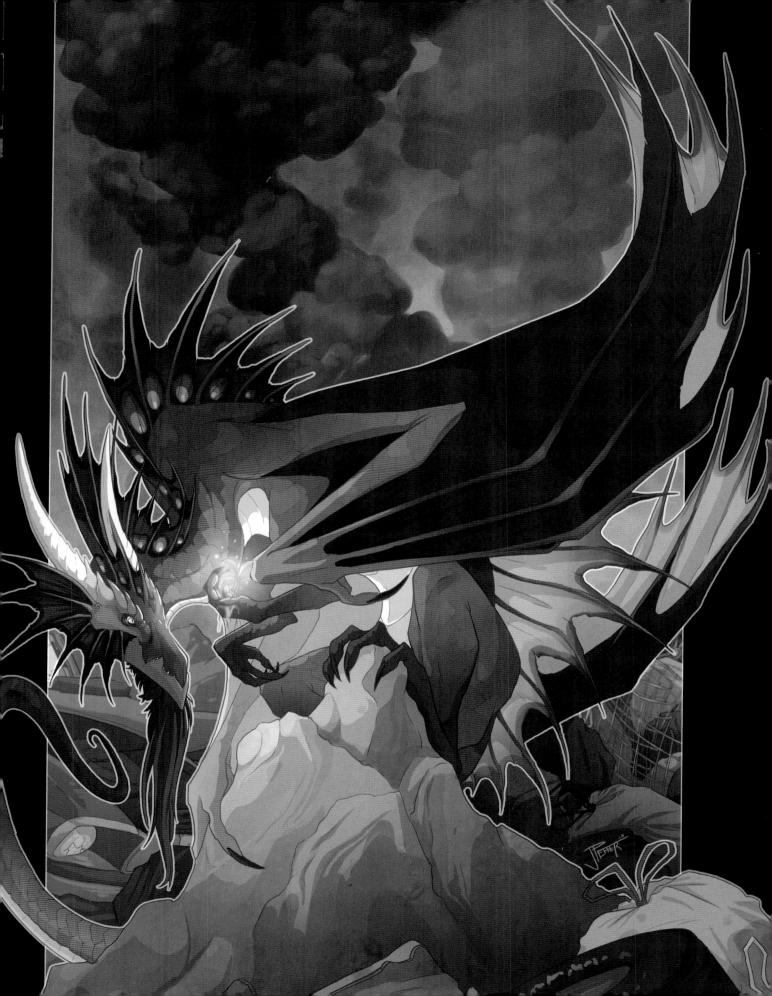

EVOLUTION OF A COVER

This was the cover art for my how-to-draw dragons book, *DragonArt™ Evolution*. I tried to create a variety of thumbnails for the cover that had the dragons front and center, while allowing enough room above for the title of the book to be read clearly.

I sent the thumbnails into the fine editors at IMPACT, and they chose the dragon battle as the cover image. It was my favorite of the four and I was pleased as punch!

I created a second round of thumbnails so the dragons were not quite so symmetrical, then went to a final—and this is the result.

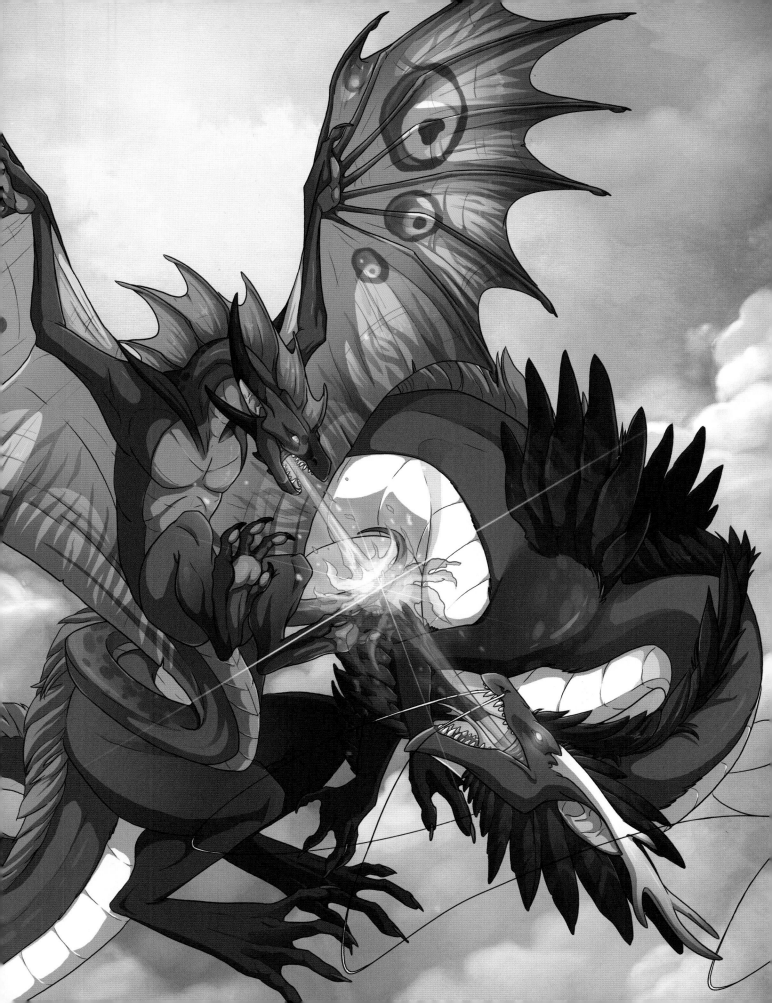

SPELLFIRE

The fireball in the dragon's claws and the spell mist circling behind him were not present in the original sketch. These were created digitally in Photoshop using several screen and dodge layers. Screen and dodge will lighten the layers below them and create an effect that seems to glow. I created the fire effect by building up a combination of soft and hard brushstrokes.

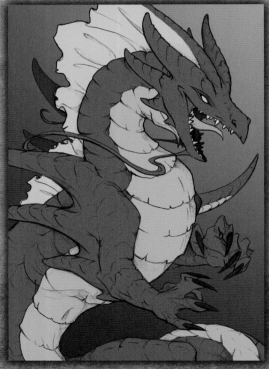
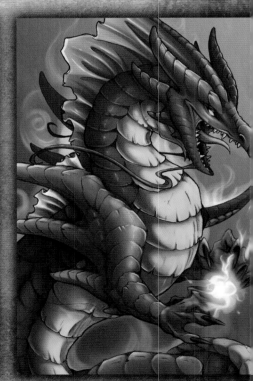

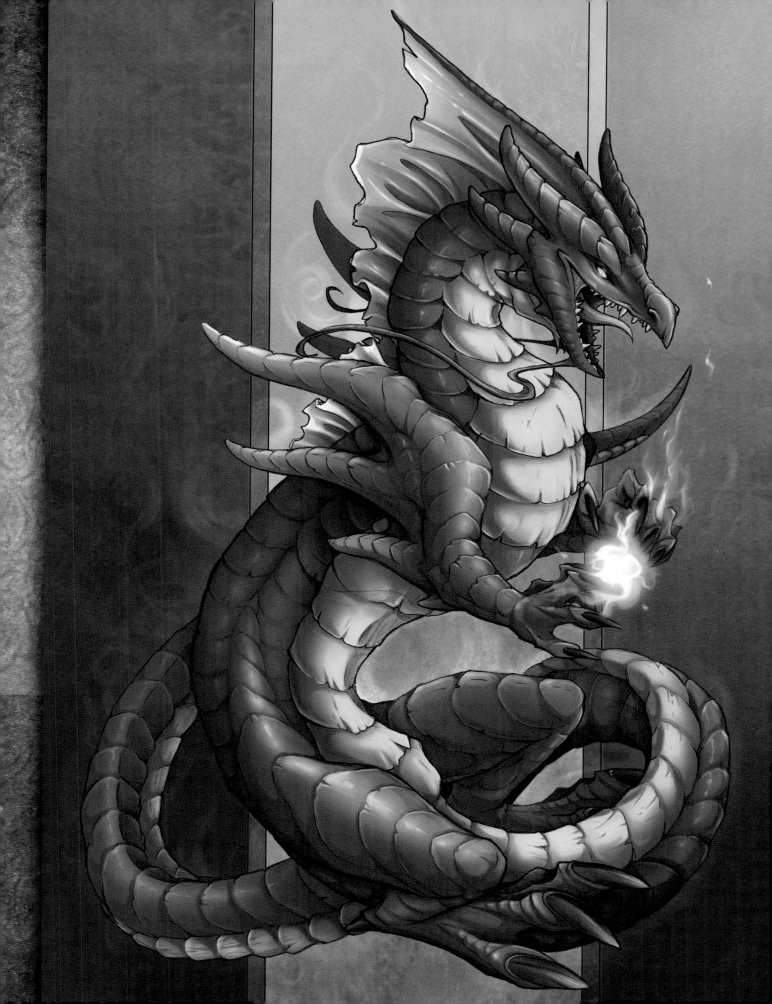

FLAME FOOT

I chose green flames for this dragon because I enjoyed the way the green color looked with the cooler teals and purples of its body. The flames on the back of this dragon could simply be caused by a lit chemical that burns green, a result that seems less painful than using its own flesh as fuel for such a combustion … though I certainly hope the little guy is fire-resistant!

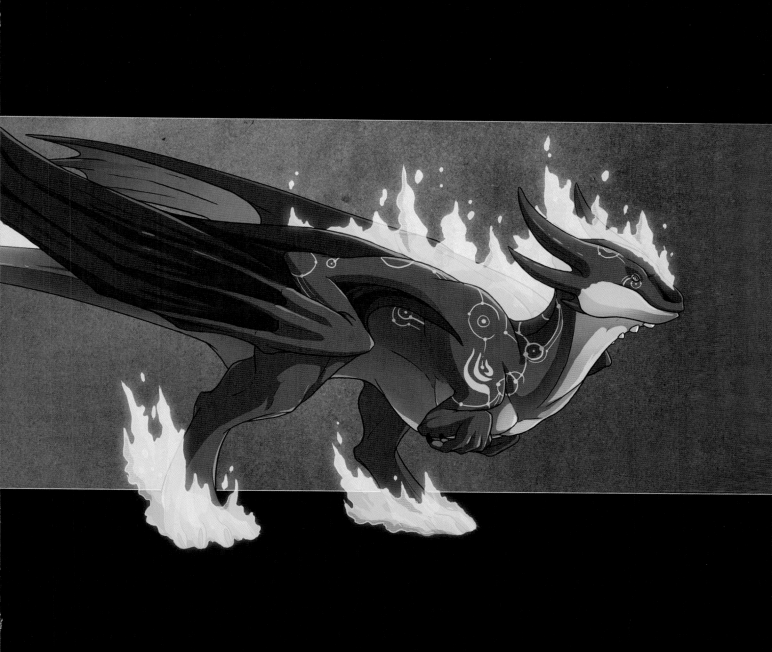

MIXED ELEMENTS

These mutant creatures are a wonderful hybrid of water, earth, air and fire, but one element always seems to dominate.

AIR

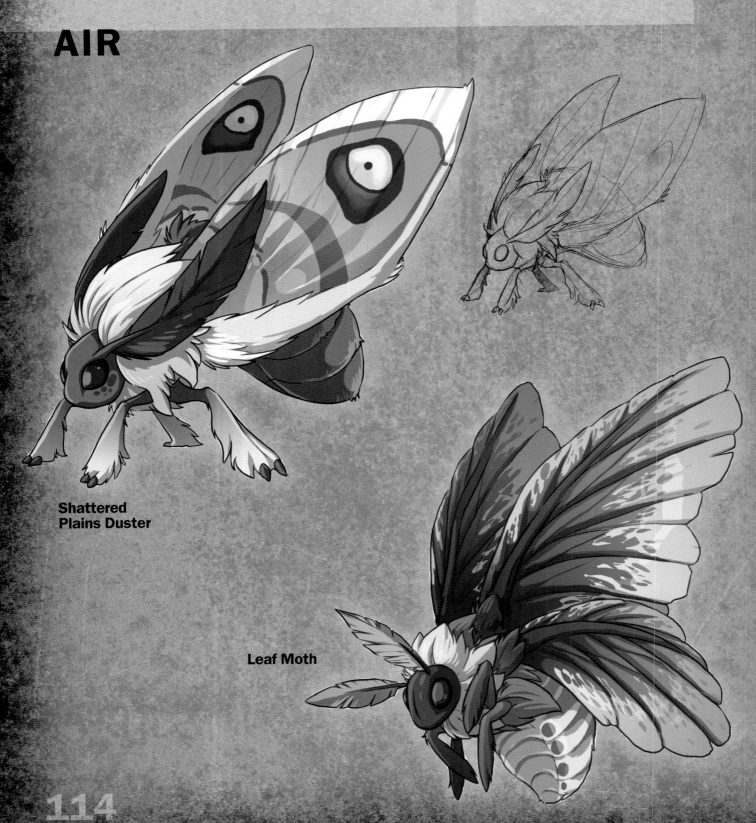

Shattered Plains Duster

Leaf Moth

EARTH

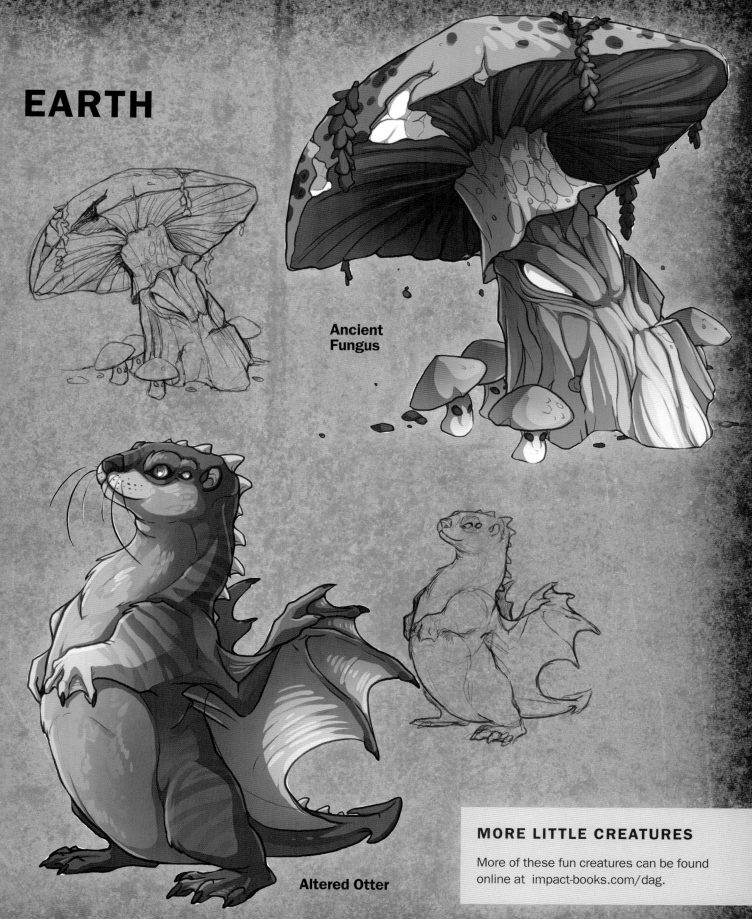

Ancient
Fungus

Altered Otter

MORE LITTLE CREATURES

More of these fun creatures can be found
online at impact-books.com/dag.

FIRE

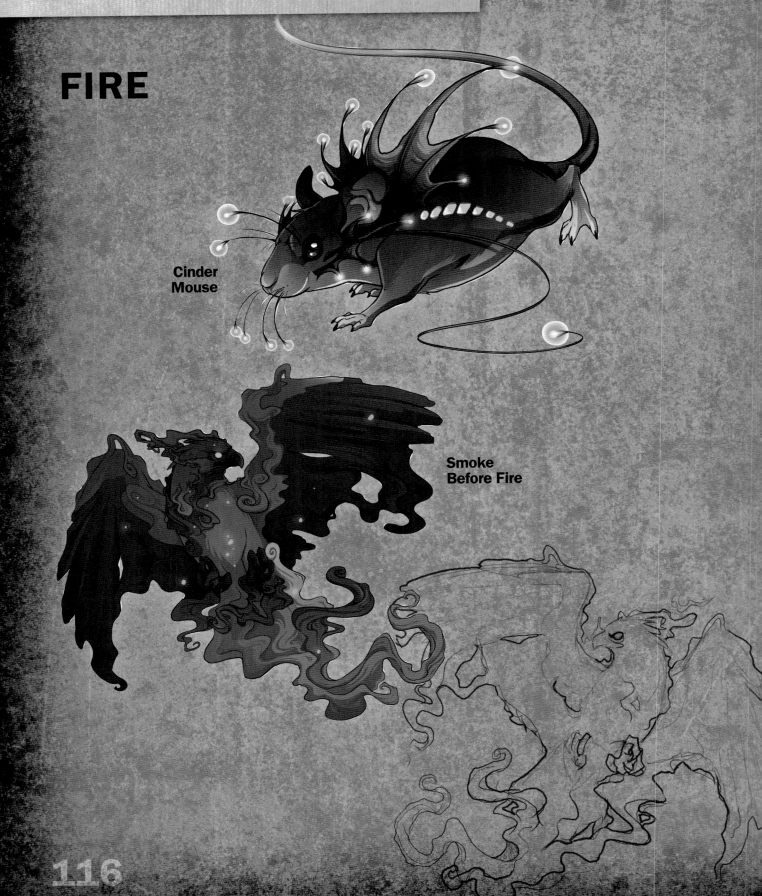

Cinder
Mouse

Smoke
Before Fire

WATER

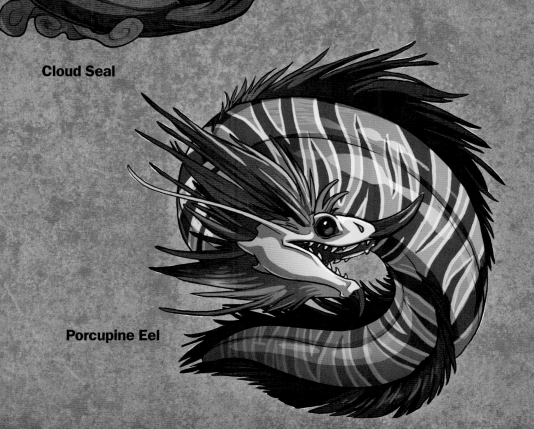

Cloud Seal

Fairy Fish

Porcupine Eel

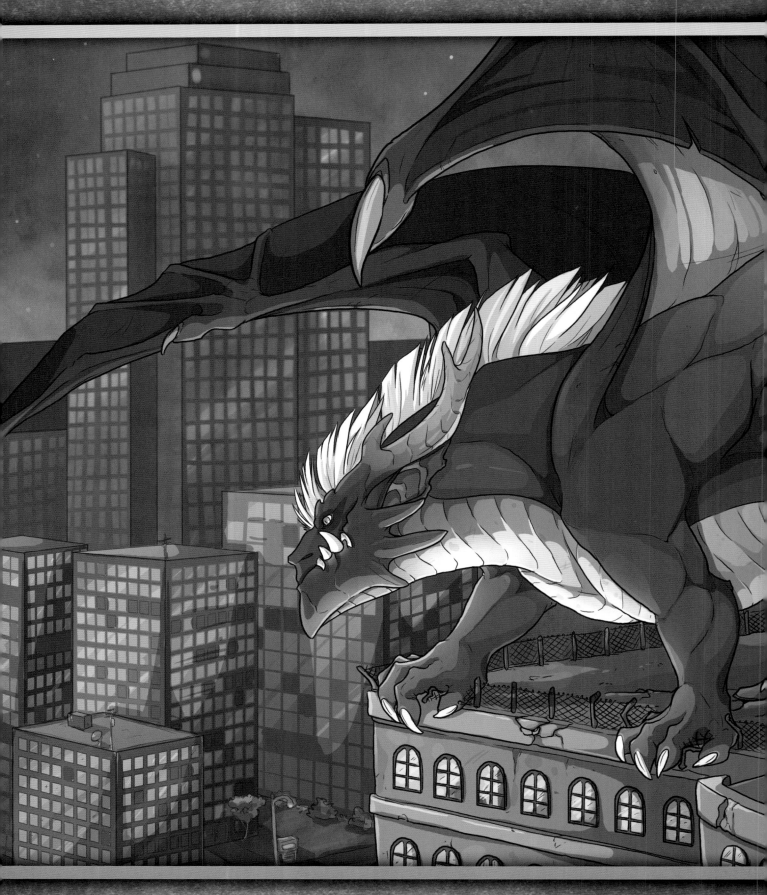

Narugi

SPIRIT

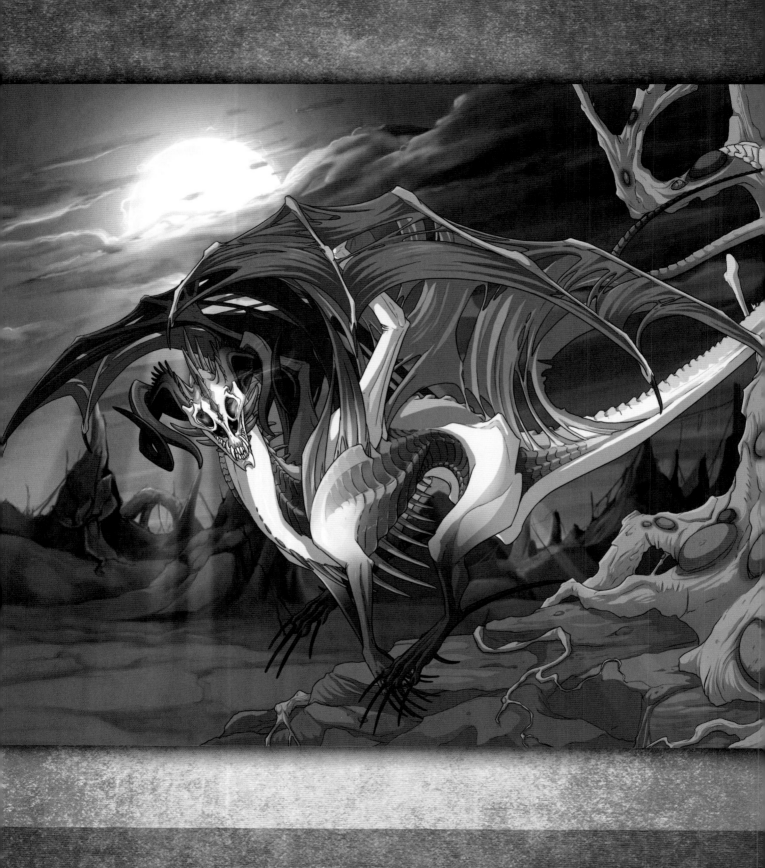

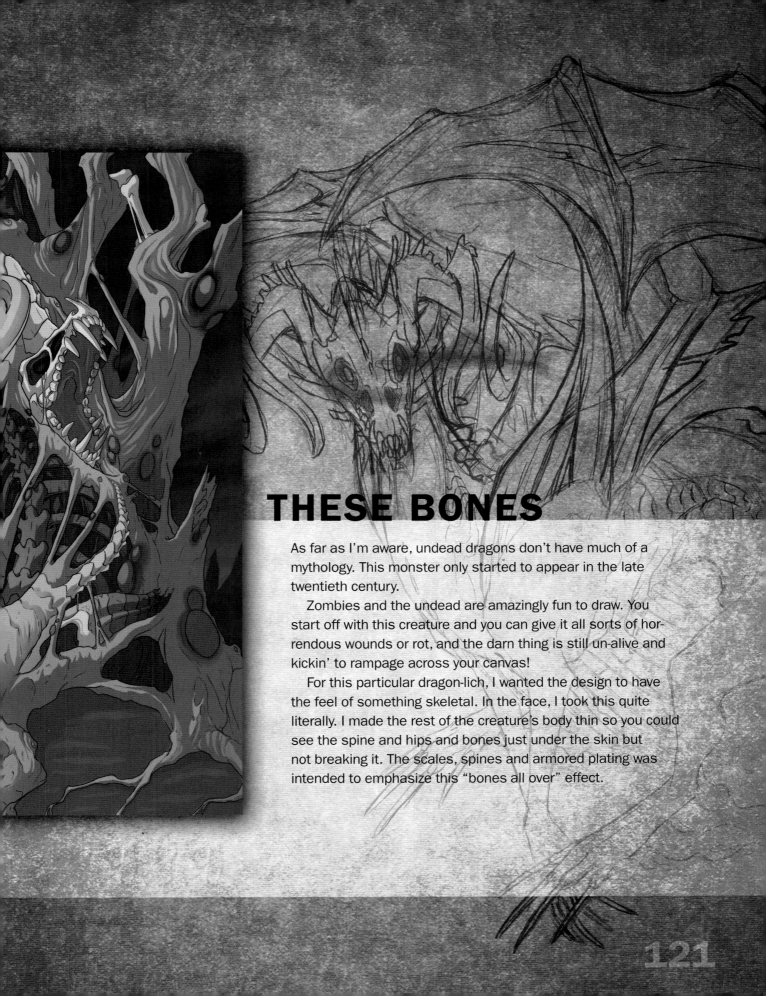

THESE BONES

As far as I'm aware, undead dragons don't have much of a mythology. This monster only started to appear in the late twentieth century.

Zombies and the undead are amazingly fun to draw. You start off with this creature and you can give it all sorts of horrendous wounds or rot, and the darn thing is still un-alive and kickin' to rampage across your canvas!

For this particular dragon-lich, I wanted the design to have the feel of something skeletal. In the face, I took this quite literally. I made the rest of the creature's body thin so you could see the spine and hips and bones just under the skin but not breaking it. The scales, spines and armored plating was intended to emphasize this "bones all over" effect.

FAIRY FRIENDLY

These fairies were part of a series where I attempted to stay closely within a monochromatic color scheme.

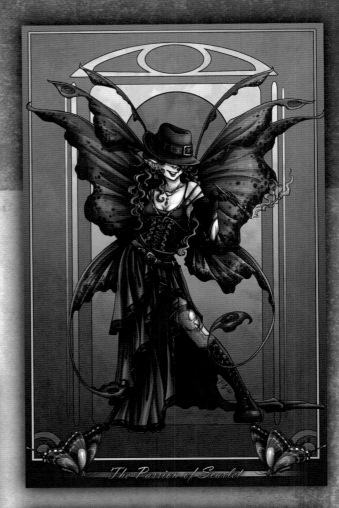

The Passion of Scarlet

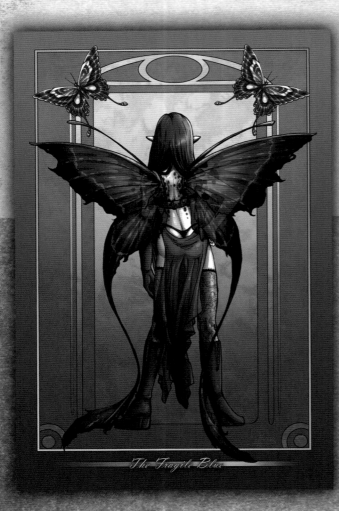

The Fragile Blue

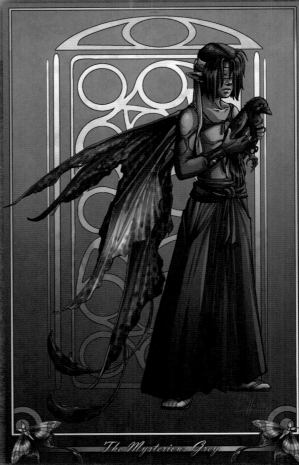

The Mysterious Grey

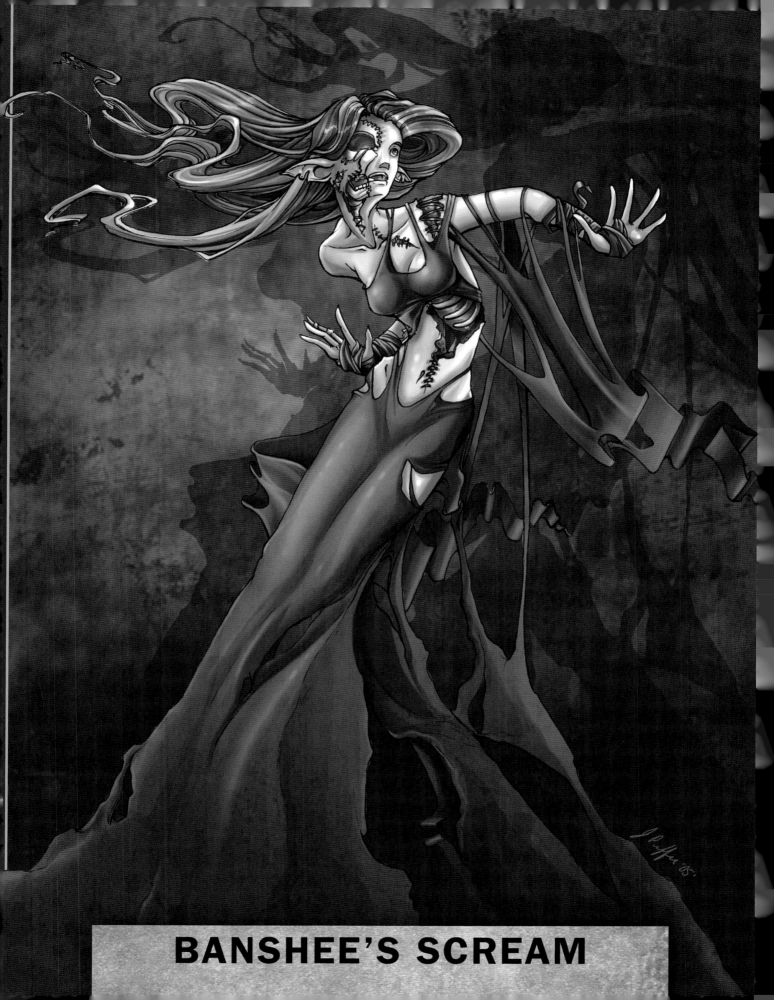

BANSHEE'S SCREAM

SHADOWS AND MIST

This was drawn as an entry for a vampire art gallery-style book. I was trying to go for a good handful of vampire elements, such as bats, crypts, spooky dresses, dark eyeliner and blood. Once I started adding colors, the image seemed to become a bit more somber. It looked like she might be a bit lonely. I decided to proceed with that reaction, rather than have a massive swarm of bats filling the rest of the canvas.

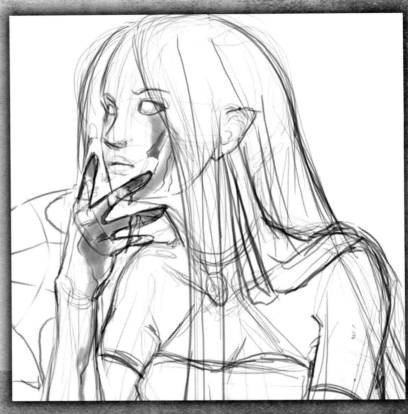

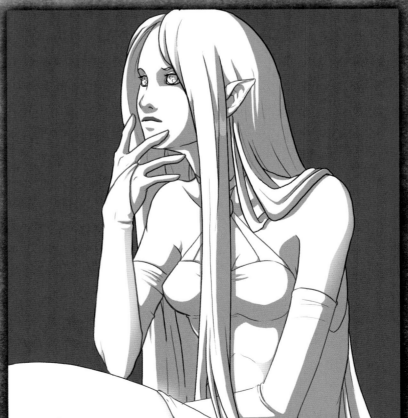

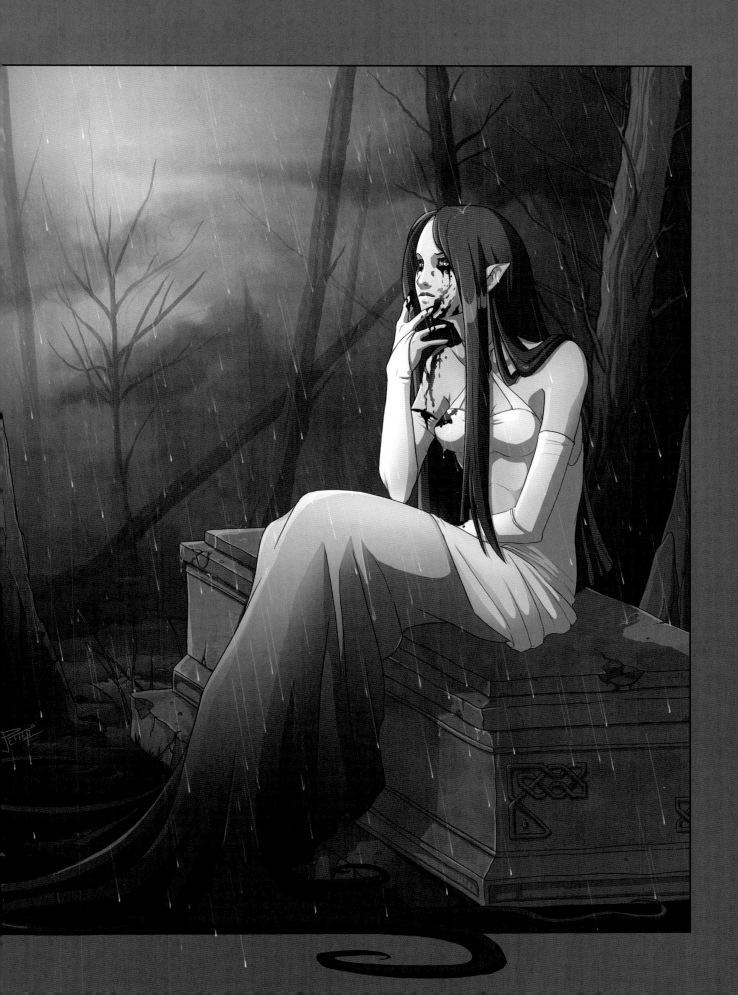

SKETCHING THE ELEMENTS

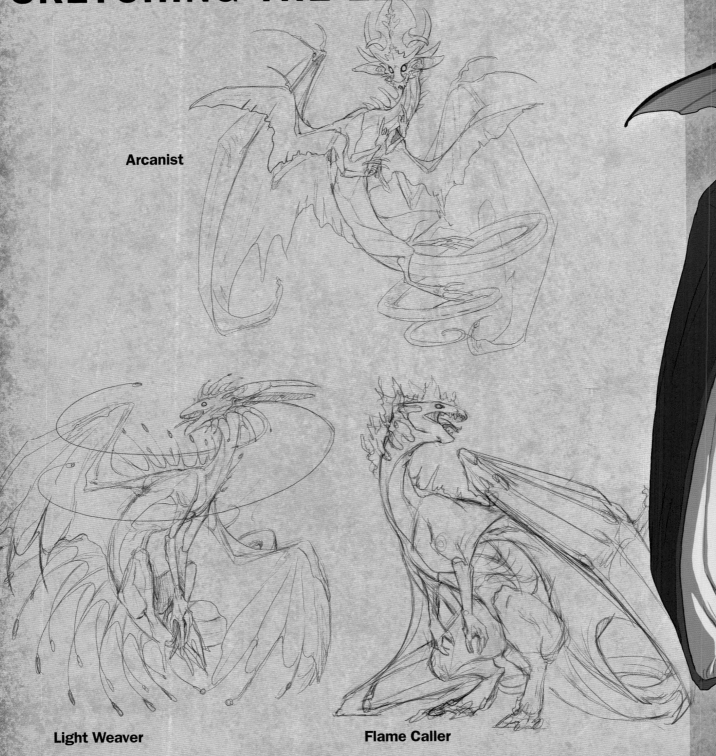

Arcanist

Light Weaver

Flame Caller

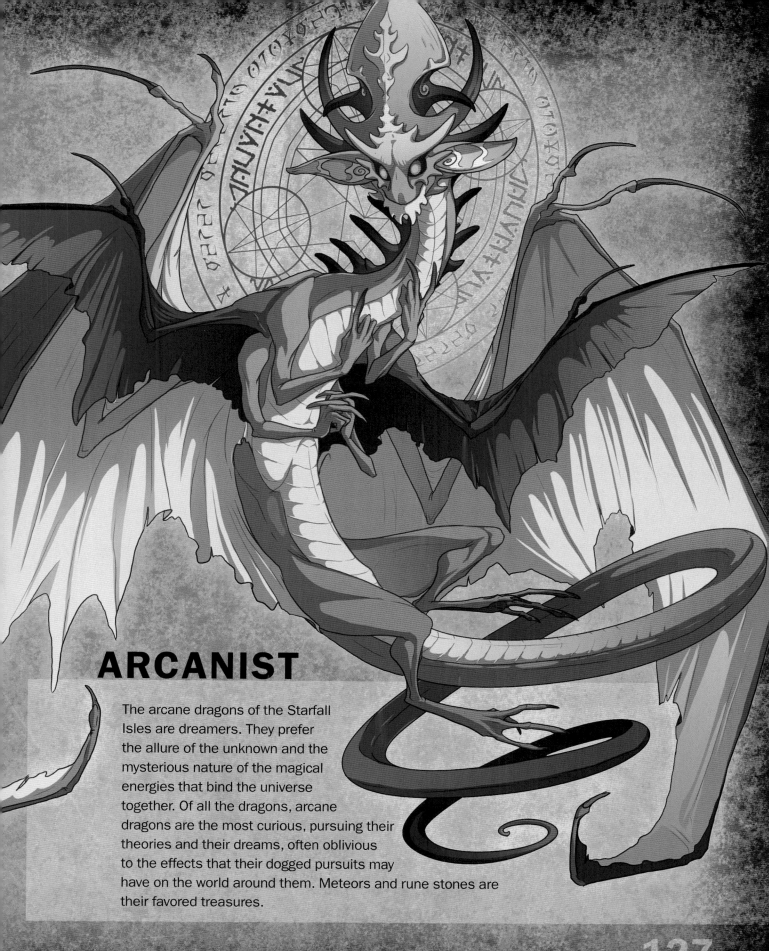

ARCANIST

The arcane dragons of the Starfall Isles are dreamers. They prefer the allure of the unknown and the mysterious nature of the magical energies that bind the universe together. Of all the dragons, arcane dragons are the most curious, pursuing their theories and their dreams, often oblivious to the effects that their dogged pursuits may have on the world around them. Meteors and rune stones are their favored treasures.

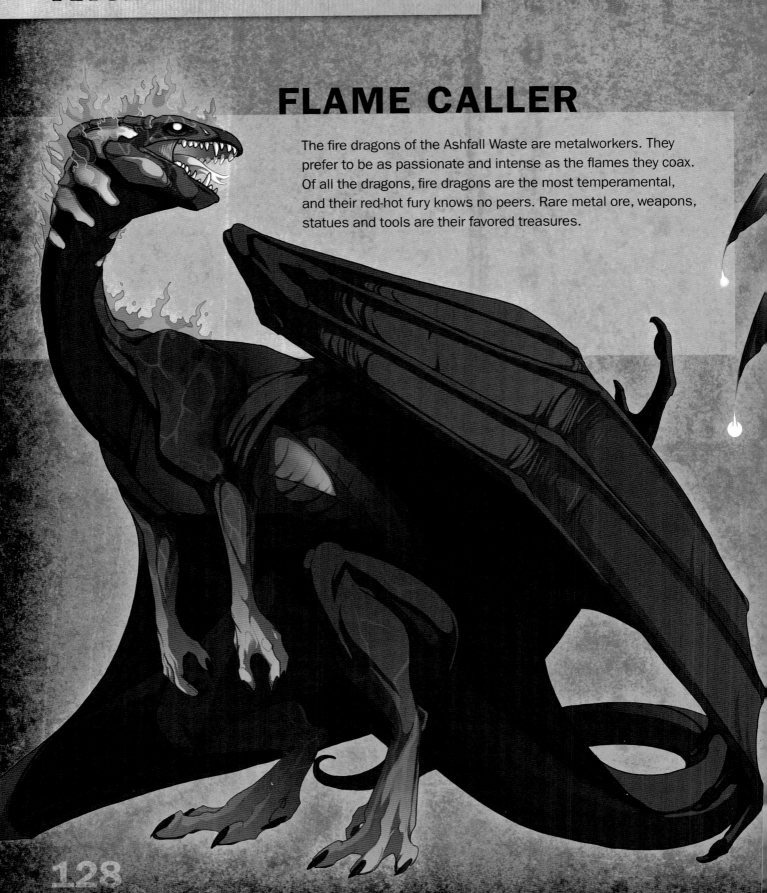

FLAME CALLER

The fire dragons of the Ashfall Waste are metalworkers. They prefer to be as passionate and intense as the flames they coax. Of all the dragons, fire dragons are the most temperamental, and their red-hot fury knows no peers. Rare metal ore, weapons, statues and tools are their favored treasures.

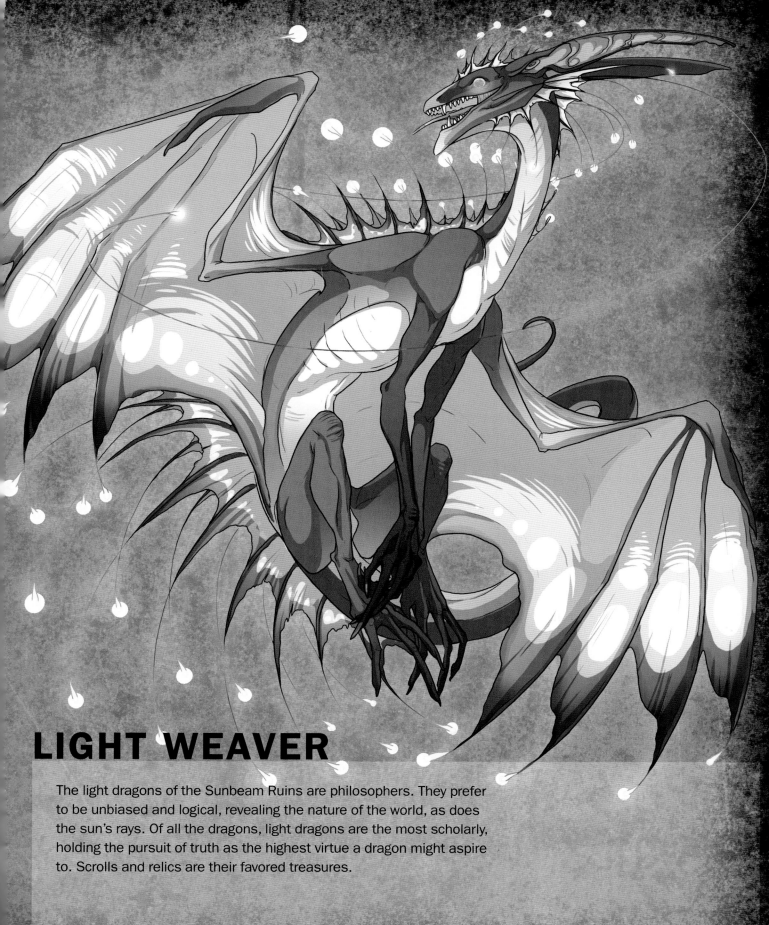

LIGHT WEAVER

The light dragons of the Sunbeam Ruins are philosophers. They prefer to be unbiased and logical, revealing the nature of the world, as does the sun's rays. Of all the dragons, light dragons are the most scholarly, holding the pursuit of truth as the highest virtue a dragon might aspire to. Scrolls and relics are their favored treasures.

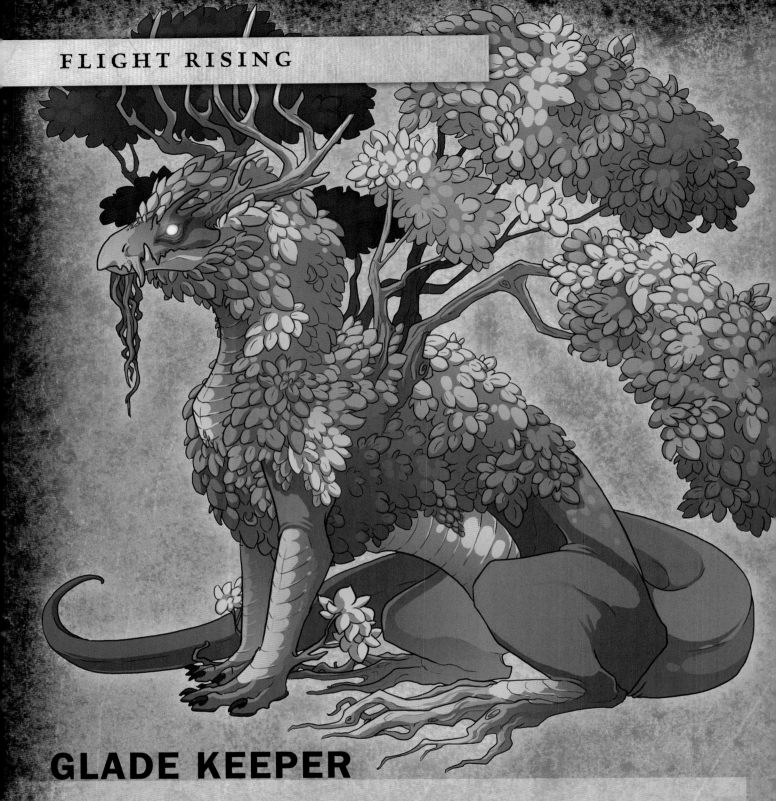

GLADE KEEPER

The nature dragons of the Viridian Labyrinth are druids. They prefer to be as wild and primal as the ancient forests they call home. Of all the dragons, nature dragons are the most nurturing, enjoying the care and cultivation of flora and fauna, spreading an overgrowth of life where once there was none. Seeds and rare flowers are their favored treasures.

EARTH SHAKER

The earth dragons of Dragonhome are monument builders. They prefer the consistency and eternal memory of the stone they shape. Of all the dragons, earth dragons revere their ancestors the most fervently and remember the most about the First Age. Gemstones are their favored treasures.

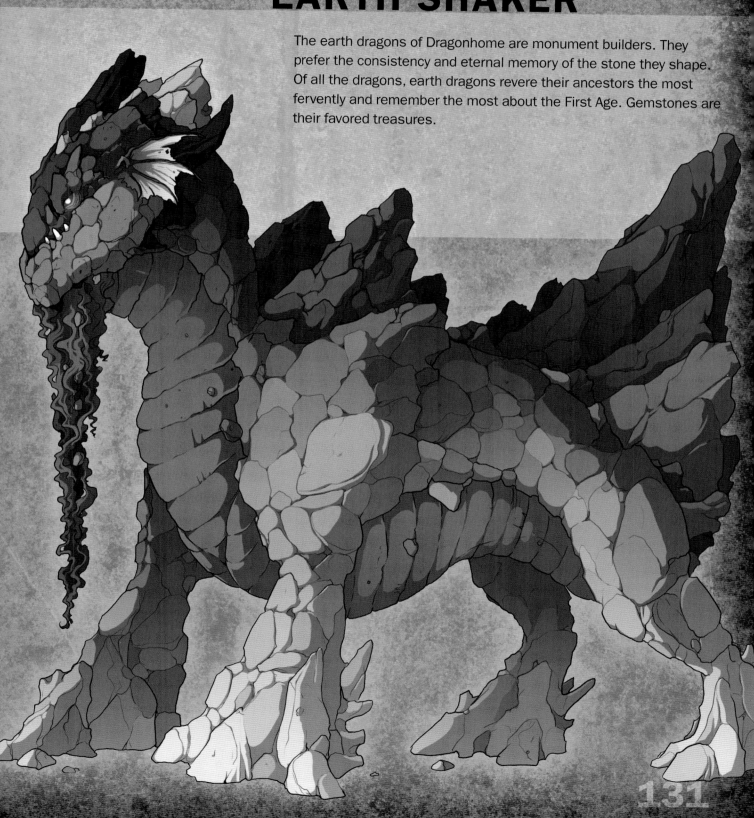

SKETCHING THE ELEMENTS

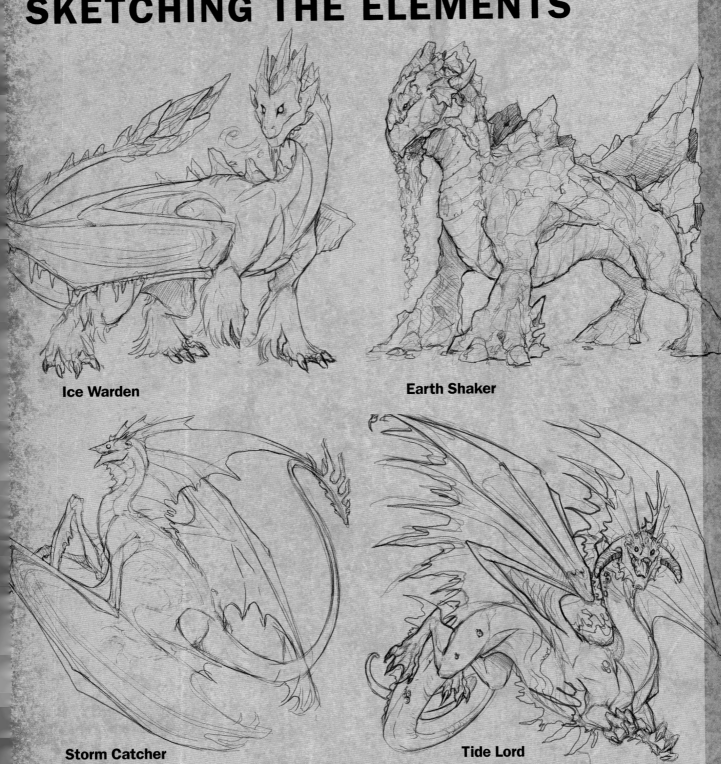

Ice Warden

Earth Shaker

Storm Catcher

Tide Lord

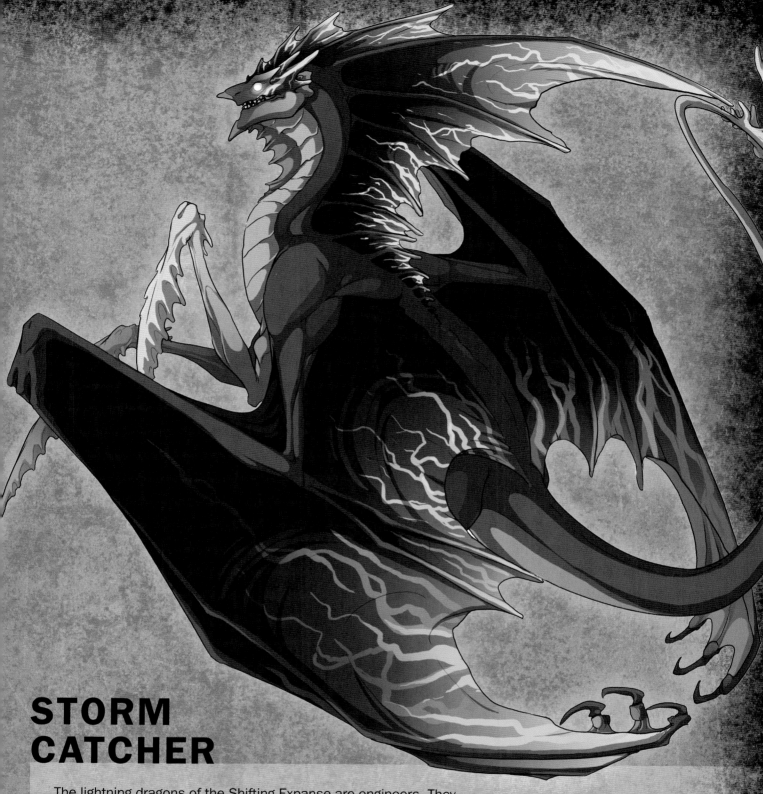

STORM CATCHER

The lightning dragons of the Shifting Expanse are engineers. They prefer to be quick and intuitive to better harness the power of the tempests under which they make their home. Of all the dragons, lightning dragons are the most ambitious, changing the world to adapt to them, rather than adapting to the world. Copper wire, tools and reactors are their favored treasures.

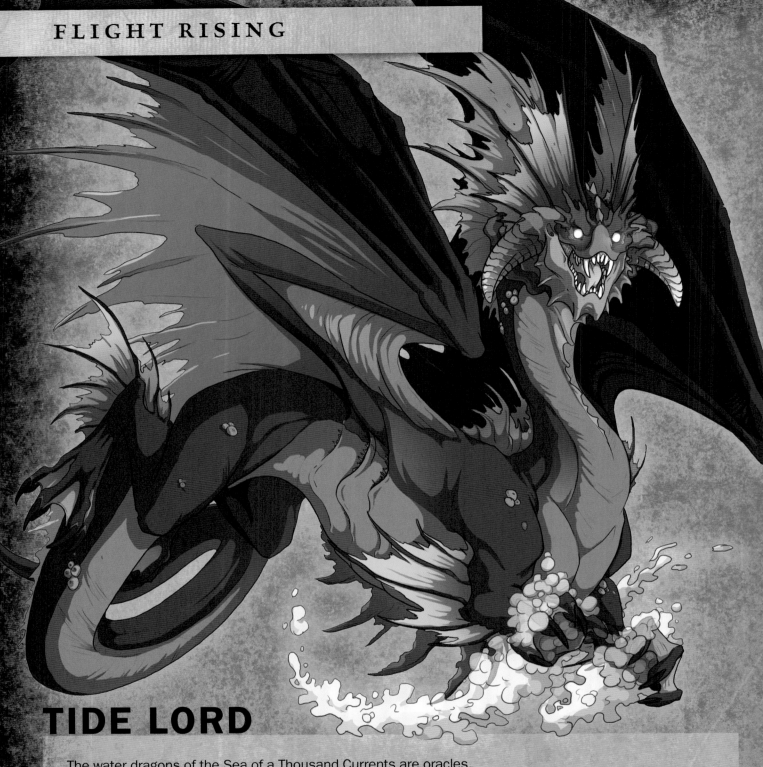

TIDE LORD

The water dragons of the Sea of a Thousand Currents are oracles. They prefer to be as fluid as the waves and currents of the oceans. Of all the dragons, water dragons are the most mysterious, predicting the many futures that may come to pass, but revealing nothing of what they divine to outsiders. Shells and magic orbs are their favored treasures.

ICE WARDEN

The frost dragons of the Southern Icefield are collectors. They prefer to be as rigid and cold as winter's chill. Of all the dragons, ice dragons are the most unemotional, carefully preserving the world around them to be later analyzed and catalogued. Fossils and artifacts are their favored treasures.

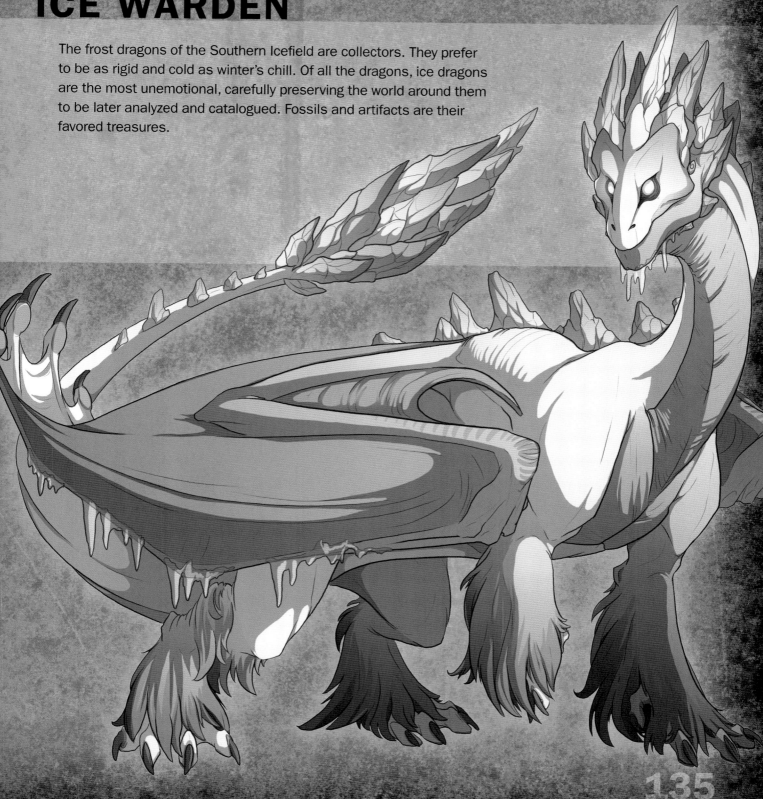

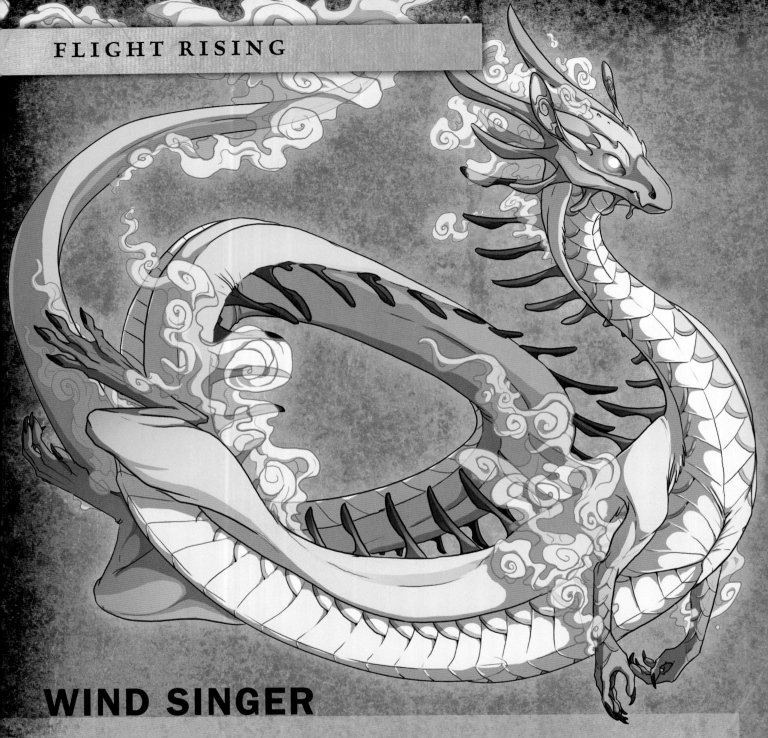

WIND SINGER

The wind dragons of the Windswept Plateau are explorers. They prefer to be joyful and carefree, like the gentle and playful breezes that whisk them to new lands. Of all the dragons, wind dragons are the most friendly, eager to become a small part of every community they encounter before they eventually and inevitably leave, following the currents in pursuit of a new adventure. Maps, compasses and feathers are their favored treasures.

SKETCHING THE ELEMENTS

Wind Singer

Shadow Binder

Plague Bringer

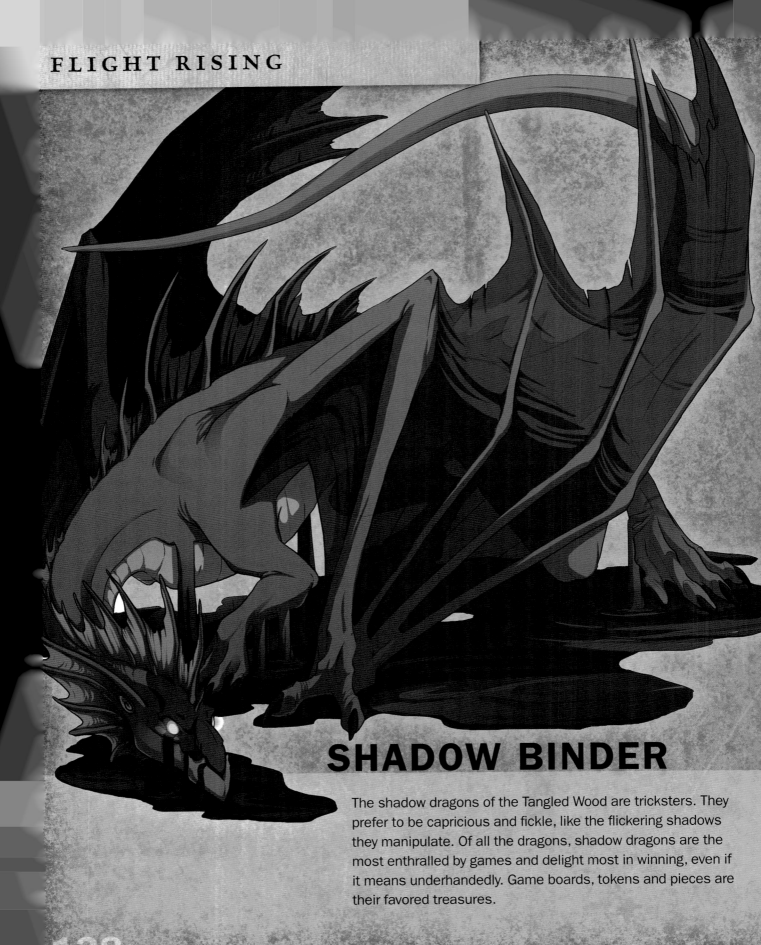

SHADOW BINDER

The shadow dragons of the Tangled Wood are tricksters. They prefer to be capricious and fickle, like the flickering shadows they manipulate. Of all the dragons, shadow dragons are the most enthralled by games and delight most in winning, even if it means underhandedly. Game boards, tokens and pieces are their favored treasures.

PLAGUE BRINGER

The plague dragons of the Scarred Wasteland are survivors. They prefer to be as strong and adaptable as the plague they spread. Of all the dragons, plague dragons are the most savage and celebrate the cycle of life and death by constantly pitting themselves against the other elements. The bones and armor of their enemies are their favored treasures.

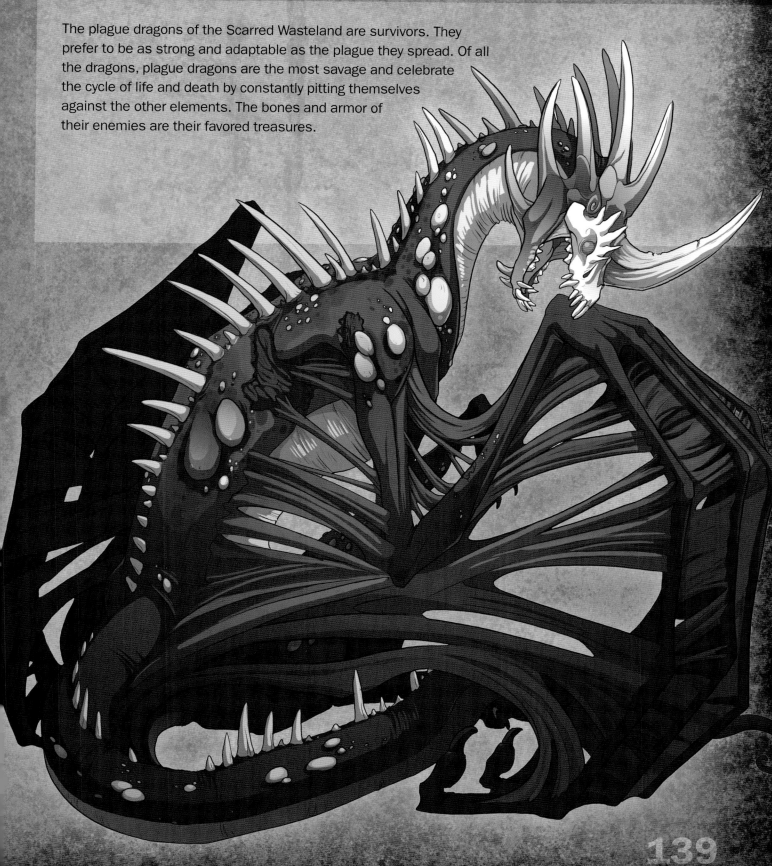

139

INDEX

About the Author

J "NeonDragon" Peffer is a fantasy art illustrator and author of IMPACT's *DragonArt™: How to Draw Fantastic Dragons and Fantasy Creature*s, *DragonArt™: Fantasy Characters* and *DragonArt™: Evolution*. She runs a popular website, neondragonart.com, a community where fantasy art fans explore her art, comics, art tutorials, products featuring her art, message boards, links and other features. Her work, which has overtones of the popular Japanese manga/anime style, has been licensed for T-shirts, posters, stickers and other items. She has also done character and logo commissions. She is a graduate of the Columbus College of Art and Design.

Other fine IMPACT Books are available from your favorite bookstore, art supply store or online supplier. Visit our website at fwmedia.com.

16 15 14 13 12 5 4 3 2 1

DISTRIBUTED IN CANADA BY FRASER DIRECT
100 Armstrong Avenue
Georgetown, ON, Canada L7G 5S4
Tel: (905) 877-4411

DISTRIBUTED IN THE U.K. AND EUROPE
BY F&W MEDIA INTERNATIONAL, LTD
Brunel House, Forde Close, Newton Abbot, TQ12 4PU, UK
Tel: (+44) 1626 323200, Fax: (+44) 1626 323319
Email: enquiries@fwmedia.com

DISTRIBUTED IN AUSTRALIA BY CAPRICORN LINK
P.O. Box 704, S. Windsor NSW, 2756 Australia
Tel: (02) 4577-3555

Edited by Vanessa Wieland
Designed by Wendy Dunning
Production coordinated by Mark Griffin

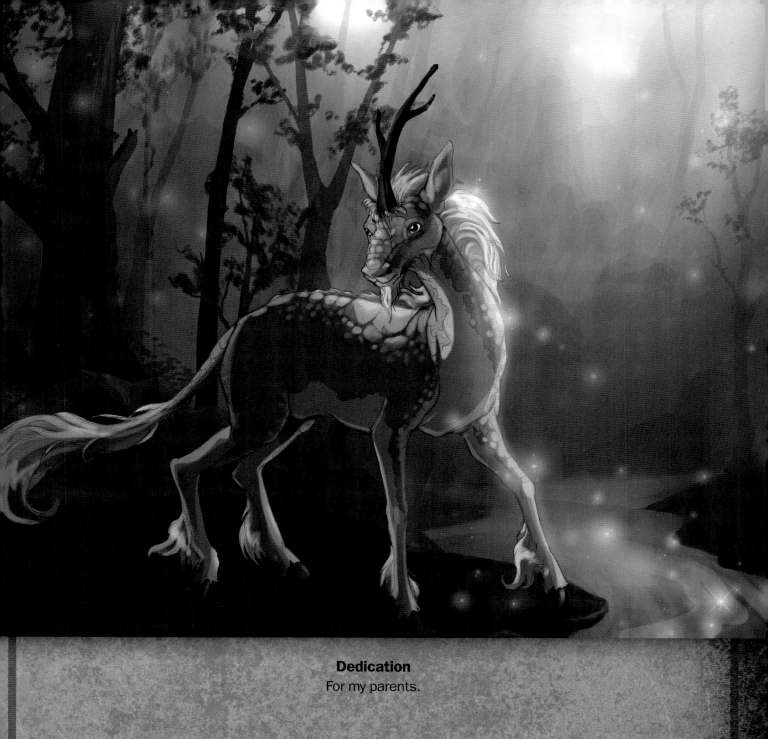

Dedication
For my parents.

Acknowledgments
Thanks to Vanessa Wieland and Wendy
Dunning. They made sense of chaos and
turned it into a tidy little book! Thanks to
CGTextures and hibbary for the amazing
texture resources.

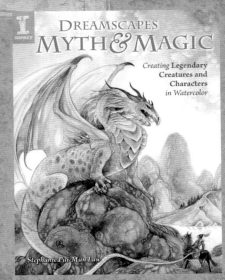